Fine Art
Photography

High Dynamic Range

Fine Art Photography

High Dynamic Range

TONY SWEET

STACKPOLE
BOOKS

Published by
STACKPOLE BOOKS
5067 Ritter Road
Mechanicsburg, PA 17055
www.stackpolebooks.com

Printed in China

10 9 8 7 6 5 4 3 2 1

First edition

Cover design by Caroline Stover

Library of Congress Cataloging-in-Publication Data

Sweet, Tony, 1949–
 Fine art photography : high dynamic range / Tony Sweet. — 1st ed.
 p. cm.
 Includes bibliographical references.
 ISBN 978-0-8117-0755-8
 1. High dynamic range imaging. 2. Photography, Artistic. I. Title.
TR594.S94 2011
775—dc22

 2010053884

For Babs, Tim, and Bob.

Foreword

THE JOURNEY INTO PHOTOGRAPHY CAN BE DIFFICULT FOR MANY CREATIVE people. It is a constant balance between the technical and the artistic. Before one can truly develop one's own style, a firm understanding of how to control the tools of photography is essential. Only after mastering their function can one begin to explore one's own inner creative drive.

With advances in High Dynamic Range digital processing, a new frontier has opened up in modern photography. This new frontier has its own set of technical challenges. Understanding how to master them is integral to understanding how they will affect your image and, ultimately, creative expression.

Tony Sweet's always-evolving work shows how new advances in digital photography can lead to exciting and creative image making. Tony has become one of the leading gurus in High Dynamic Range photography, quickly absorbing and masterfully applying the wide range of processing techniques available in HDR. Whether it's understanding field techniques to capture the most dynamic range in a scene or mastering the many post-processing looks, Tony will guide you through all the steps to achieve the desired effect.

His work is inventive, instinctive, and inspiring. But what makes Tony stand out in the field of photography is his generosity in sharing what he has learned with other photographers, both amateur and professional. He has an infectious excitement about creating images and that is passed on to those who have studied photography with him.

You could not have picked a better mentor to start your journey into High Dynamic Range photography with than Tony Sweet.

—*Gregory McKean*
www.MasterPhotoWorkshops.com

Gregory's series, Master Photo Workshops, has released ten feature-length video titles on photography ranging from classic landscape techniques to advanced digital processing and High Dynamic Range. The series features top working professionals teaching their craft in the field and in the studio.

Prelude

HIGH DYNAMIC RANGE PHOTOGRAPHY HAS BECOME A STAPLE IN MODERN digital photography. It seems that everyone is generating HDR images these days. HDR images are all over online photo sites such as Betterphoto.com, Flickr, Smugmug, Photobucket, Picasa, Webshots, and so on. It's become apparent to just about everyone that HDR has possibilities for image making that are finally accessible to any photographer using any digital camera from point-and-shoots to high-megapixel pro-DSLRs.

It may be interesting to know that HDR is not new. Not even close. Here's a brief history: The first recorded photograph that was the result of combining two images to achieve detail in the brightest and darkest parts of an image was created in 1850 by Gustave Le Gray. This technique is still practiced. What is known today as HDR was was originally developed in the 1930s by Charles Wyckoff. Wyckoff's detailed pictures of nuclear explosions appeared on the cover of Life magazine in the mid 1940s. Wyckoff implemented local neighborhood tone remapping to combine differently exposed film layers into one single image of greater dynamic range. After the development of the radiance image file format (RGBE), tone mapping made it possible to display HDR images on computer monitors. This technique was presented to the public by Paul Debevec in 1997.

It was then a short trip to 2005, when Photoshop CS2 introduced the Merge to HDR function. Soon after this, what would soon become the industry standard for HDR software, Photomatix, entered the marketplace. Many HDR programs followed. Among these are Artizen HDR, FDR Tools, Hydra, and Dynamic Photo HDR 4, with more appearing, it seems, daily. The latest entry into the HDR software arena is Nik's HDR Efex Pro. This is professional-level software on par with Photomatix. For the purpose of this book, we'll be dealing with Photomotix and HDR Efex Pro exclusively. These two HDR programs are currently the choice of a great majority of professionals and serious amateurs. Many other HDR books have comparisons between the various HDR software, so that information is readily available. This book will forego comparisons, instead focusing on practical settings in many different shooting situations using the two most popular HDR programs being used today.

HDR can have a stylized "look," which can be the subject of debate in photographic circles. The range of HDR interpretations can vary wildly from absolute realism where the HDR intervention is invisible, through various levels of the HDR look to a complete departure from photography into the realm of nonrepresentational work. It's all up to the maker. The important thing is that high dynamic range photography is a potent tool in our ongoing pursuit of higher levels of creative expression.

In the real photography world, stock photography agencies tend to shy away from HDR images, as many of them look overprocessed. But it is possible to use HDR to achieve a much less artifical look, replicating what we see naturally. I've had natural-looking HDR images accepted readily and without question by stock agencies. However, I also like completely nonrepresentational interpretations, completely straying away from the photographic look. There are many people waiting to get in your face about the merits of the "natural look," as opposed to the "phony" HDR look, but these are easy arguments to debunk. To paraphrase the great John Shaw, "If I want to record things as they are, I'll look at them." Glass filters, graduated NDs, color biases in films, processing techniques in digital, many raw converters that render differently, and so on, all alter the natural look of an image and move images into the realm of interpretation. The interpretive process is paramount in photography—otherwise, why not just take snapshots?

The bottom line: High Dynamic Range has gained a permanent place with ever-increasing importance and popularity in modern digital photography. The sooner we get a handle on it and add it to our workflows, the easier it will be to adapt to it and blend it into the future of photography, and more importantly, to create images that used to only reside in our imaginations.

Let's start with some basic information.

Equipment recommended for high quality HDR photography:

Tripod, tripod head, and cable release. A good tripod and tripod head should cost as much as a good, fast lens. Stability, flexibility, and endurance are what are important. And of course for maximum sharpness, it's a good practice to use a cable release instead of manually pressing the shutter release for each exposure. Of course, if you forget your cable release, you can use the camera's self-timer.

Optional panning head. This is used in creating HDR pans. I have two tripods, one with the Really Right Stuff Panning head and the other with the Gitzo leveling head.

(More about equipment can be found in the appendix.)

Camera. Your camera should have the following capabilities:
- Should be able to bracket in increments of 1 stop
- Exposure compensation should go to at least −3
- Auto bracketing is a convenient option
- Lowest ISO possible (ISO200 should be the highest low ISO). The lower the ISO, the less noise is created.
- Should have a histogram to check exposures. In the exposure series, one image must have all highlights captured (histogram shifted to the left, leaving a small opening at the right), and one image must have all shadow detail captured (histogram shifted to the right, leaving a small opening at the left).

Software. In order to create HDR images, you'll need a RAW processing software—ACR (Adobe Camera Raw), Lightroom, Aperture, Photo Mechanic, or a similar program—and an HDR processing program. In this book, we will be using the two most popular HDR programs as of this writing: Photomatix and HDR Efex Pro. We'll begin by having a close look at Photomatix.

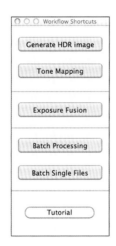

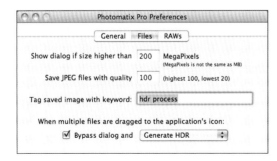

Photomatix

http://hdrsoft.com

Let's get Photomatix configured by setting the preferences. There are three tabs:

General

The two most important settings to have checked are "Show at start-up: Workflow Shortcuts" and "Start Tone Mapping with settings of previous session" when beginning the process. Workflow Shortcuts is a quick and easy menu of operands, which can save time finding them each time in the dropdown menus. If the "Start Tone Mapping . . ." button is selected, the previous settings will be applied to the next image's tone mapped box. That's why it's always a good practice to begin each tone mapping session by pressing the Default button at the bottom of the window to start fresh. However, in the case of HDR pans, which I do frequently, it's an invaluable setting. In a series of HDR images that will be compiled into a panoramic image, the settings on the first image will automatically be applied to each successive image in the series when it is opened in Photomatix. This results in uniformity and a seamlessly stitched pan image.

Files

The top two default settings are good. The Tag Saved Image with Keyword is set to "hdr process." This enables me to easily search for saved HDR tiffs. The "When multiple files are dragged to the application's icon" is checked. That tells the software to bypass the initial dialogue box and go directly to generate the HDR file, saving one step in the process.

RAWs

In the RAWs tab, I set the
"Demosaicing quality" to
High in the dropdown menu,
which is the preferred setting
if processing RAW files. For
greatest image quality, I rec-
ommend RAW files for HDR
processing; however, opinions
may vary on this. I leave the
White balance and color space
at the default setting. I check
"Reduce chromatic aberra-
tions," which refers to the red/cyan color fringing around the edges of very
high contrast situations. For example, a red/cyan outline will often appear
where very bright and very dark areas intersect in an image. This can also be
addressed in Aperture 3, Lightroom 3, and Adobe Camera Raw. I have the
Reduce chromatic aberrations and Reduce noise checked, but either can be
turned off in the Generate HDR options box. Noise reduction can also be
applied using specific software, like Nik Software's Dfine 2 (my preferred
software); Noise Ninja and Noiseware are also both excellent choices.

 Now, let's get into the workings of Photomatix. Aside from working with
Photomatix, we will only be working in the Details Enhancer. The Details
Enhancer allows you to do everything that can be done in the Tone Compres-
sor, and much more.

 Note: For a single HDR process, it's a good practice to always start by
pressing the Default button at the bottom of the Tone Mapping window. This
wipes out the settings from the previous image and starts fresh. Pressing the
Default button gives you what Photomatix "thinks" is a natural look. It is very
good in most cases and only requires minor tweaking to render a natural look-
ing HDR image.

 However, if you are processing an HDR stitched panoramic image, each
successive HDR image will open with the previous image settings, saving you
the time of reprocessing and matching the settings of the previous image. In
the case of processing HDR pans, do *not* press the default button, but imme-
diately process the image. That will keep the same settings for every image in
the HDR stitched pan, and greatly speed up the HDR pan processing time.

Tone Mapping Settings

Strength: Quite simply this tends to exaggerate the HDR effect at a high setting. I normally set strength to 85 or higher. Lowering the strength setting results in a more natural-looking image.

Color Saturation: globally increases saturation. Settings depend on the image. In most cases, adjust to taste.

Luminosity: An increase tends to brighten the image. Lowering Gamma or raising Microcontrast can balance this out by darkening the image.

Microcontrast: Will exaggerate detail and darken the image. Raising Gamma or Luminosity will balance that out.

Light Smoothing: Low light smoothing will result in unattractive halos. Increasing Light Smoothing will diminish the halos and create a more visually pleasing image.

 I avoid the Min and Low Light Smoothing settings as they are too flat, but try them to see for yourself. I usually use Mid, High, or Max, and I use High 90% of the time.

White and Black points. I set these to the first mark to have a small amount of pure white and pure black in the image. To cleanly increase contrast, rather than using microcontrast, which can be a bit grainy, you can begin with the white/black points at the same setting and increase equally. However, I use the minimal setting and deal with contrast in postprocessing.

Gamma: This is global brightness. Everything gets brighter or darker as you move the slider.

Temperature: Same as white balance. A higher setting is warmer and a lower setting is cooler.

Saturation highlights / saturation shadows: If the color is a bit exaggerated, you can tone it down with one of these sliders. It's a bit difficult to know what the software considers highlights and shadows at times. If one slider doesn't give you what you want, try the other.

Micro-smoothing: For the grunge look, turn this off. For a more natural look, canceling out microcontrast, turn the slider way up.

Highlight smoothness and Shadow smoothness: These are most useful for smoothing out the grain in skies, which is an issue with HDR. Very effective.

Shadow clipping: This can be used to blacken shadow areas, but this is handled more effectively in postprocessing.

Generating an HDR Image

Based on auto-bracketing, Nikon has to do five exposures in 1-stop increments (−2ev, −1ev, 0ev, +1ev, +2ev).

Canon can do three exposures in 2-stop increments (−2ev, 0ev, +2ev). In most cases, I'll manually bracket as the over- and underexposures may not be symmetrical.

Let's have a look at these controls and settings and how they interact by processing a standard five-image HDR series.

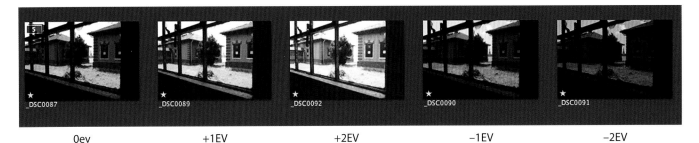

| 0ev | +1EV | +2EV | −1EV | −2EV |

After shooting your HDR series, next is to get the RAW files into Photomatix. Using Bridge and Lightroom, one can simply drag the RAW files from the application window onto the Photomatix icon (drag and drop, no problem). With the Apple/Macintosh-specific software Aperture, which is my software of choice, the RAW files have to be exported as Master Files. Go to File>Export>Master and designate a folder where the images are to be placed. After completion of the export, the RAW files can be dragged onto the Photomatix icon in the exact same fashion. One can also select "Generate HDR Image" from the Workflow Shortcut menu or by pressing the Process menu from the menu bar and selecting "Generate HDR . . ." In each of these methods, the point is to get to the "Generate HDR - Select source images" box, which shows what images have been selected. I generally count the number of files to make sure, in case I missed one (it's happened).

After OKing this out, the "Generate HDR - Options" box appears. I don't do a lot here. I check the "By matching features" radio button and the "Reduce chromatic aberrations" check box. Chromatic aberration, aka CA, is the red to cyan outlines that occur when a very bright area and a very dark area converge.

Before this feature came out, one could go through magnifying to pixel size and cloning out all of the CA. Not an insurmountable task, but you really need to like an image to do it! Or one could run the images through Adobe camera raw, tone down the CA there, and process the tiff files in Photomatix with no noticable difference from processing RAW files.

I have the "Reduce noise" box unchecked, preferring to perform that process in Nik's Dfine.

Note: Shooting at high ISOs will dramatically increase noise, perhaps to the point of unusability. Shooting at your camera's lowest ISO is the best way to keep the noise level as low as possible, reducing cleanup time and miminizing image degradation. The modern DSLRs have much better higher ISOs than earlier generations, but I still wouldn't venture above ISO400.

The "Attempt to reduce ghosting artifacts" feature is interesting. People expect miracles here. It can work quite well on slightly moving people. But it won't produce what one may expect for moving water, flowing flags, or flowers gently blowing in the wind. Actually, rather than shying away from shooting HDR in these conditions, go ahead, even using longer exposures. These conditions can create some interesting and very cool effects, which you'll see in the second part of the book.

I keep the "Take tone curve of color profile" checked, as it was recommended and I've seen no reason to change it. White balance is set to "As Shot," and the "Color primaries HDR based on" set to "Adobe RGB." I've had some dramatically oversaturated images when choosing ProPhoto RGB. If you experience the same, dialing it back to Adobe RGB should work.

When everything is set, press "Generate HDR." There's a lot of number crunching going on, so it's not uncommon for the generation phase to take as long as a few minutes. When the radiance file appears, it looks a bit strange,

X:1636 Y: 758 Lumin: 7.377
R: 7.004 G: 7.813 B: 5.883

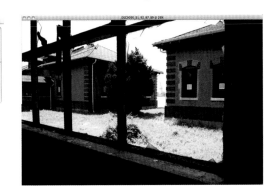

but by passing the mouse over the image, you can see a temporary tone mapped image in the HDR viewer, to the left of the image window. This is particularly useful to check out the alignment and movement in the image. It's quicker to remove one or more images and re-generate the hdr from this point, than to discover problems after proceeding to the Tone Mapping window.

In the examaple images, the mouse (not seen) is actually in the darkest part of the trees near the center of the frame.

At this point, select "Tone mapping" in the Workflow shortcut window or go to "Process" in the menu and select "Tone Mapping." When the Tone Mapping Settings box opens, make sure that the Details Enhancer tab is selected and not the Tone Compressor. For the purposes of this book, we will only be working with the Details Enhancer settings.

Note: The controls in the Details Enhancer window are set to the previous image's adjustments. You can choose to begin to fine-tune the adjustments from this point or press the Default button at the bottom of the window.

The Default button in Photomatix Pro has the distinction of being the easiest way to render a natural HDR image. However, some postprocessing work will still be required. Actually, HDR image compilation is only the first step in HDR image creation. Every HDR image will require some postprocessing using image editing software, such as Photoshop and Elements, and possibly plugins, such as LucisPro, Nik Software, AlienSkin, Topaz, and so on.

Here is the non-adjusted, more natural looking HDR image generated by pressing the Default button, before tone mapping:

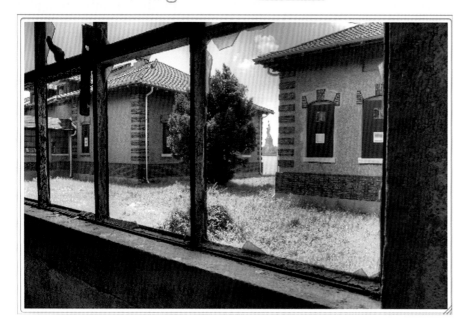

Step 1: Set white and black points to 0.010. This is to add a little working contrast by creating a small bit of pure white and pure black in the image.

Step 2: Skies can pick up some patching in the HDR process. There is an example of this in the upper right corner of the frame. A simple fix is to simply increase the Highlights Smoothness, in this case, to 80.

Step 3: There's a lot of detail in this image: the foreground wall and window frames, the bricks and textured walls, and the ornate roofing. I choose to increase Strength to 80 and Microcontrast to 6 to bring out that detail. This combination can also increase contrast if pushed too high, so Gamma had to be increased to .848. At this point, the sky is even. There's detail on the inside wall and outside. The cloud is not blown out. I will normally do critical work in color, contrast, white balance, and sharpness in photoshop and using photoshop plugins (discussed later).

Here's the Photomatix output:

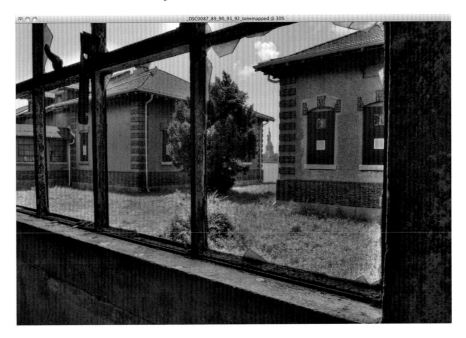

Looking at this image critically, I think it's flat and needs saturation, contrast, and selective detail enhancement. This is basically true for all HDR output from Photomatix. Opening the image in Photoshop, Nik's very cogent plugin, Viveza 2, can be used to finish off the image.

Using Nik Software's Viveza 2, I was able to drop in a series of control points to bring this image to life. First, I globally increased contrast and saturation to about 15%. Then, I used a series of control points to darken the sky, tone down certain parts of the grass, enhance the reds, increase contrast in the Statue of Liberty area, and darken and saturate the small patch of water, and used white balance to selectively warm up the walls. All of this could have been accomplished in Photoshop using a separate maneuver for each adjustment. With Nik's Viveza 2, all of this was accomplished in a fraction of the time on one screen. The small dots on the screen capture are the control points.

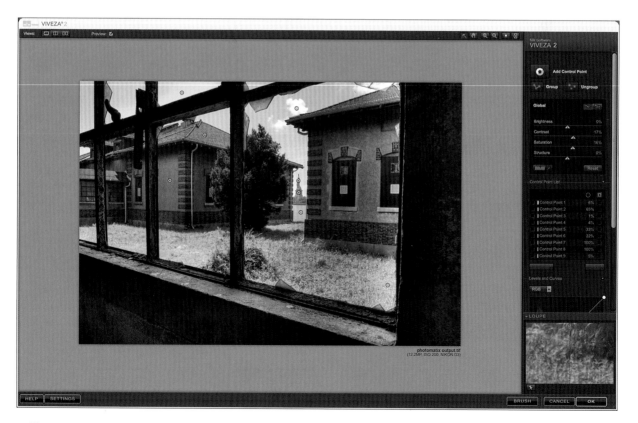

Compare this to the Photomatix output image on the previous page.

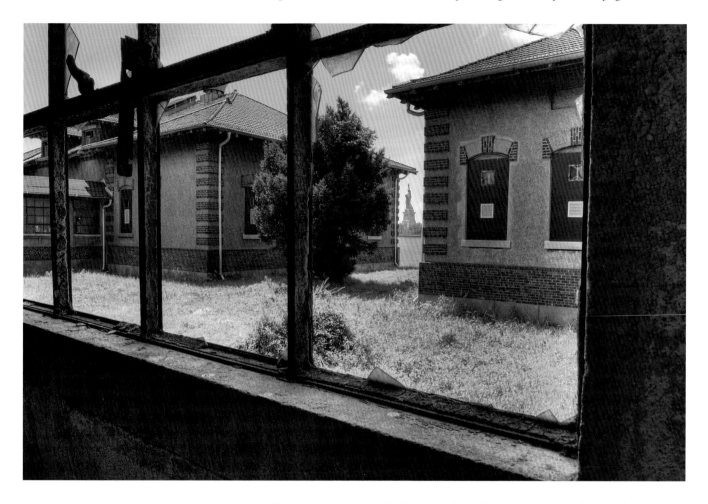

Despite the seemingly large number of adjustments, each contol point addressed a specific issue. It's best to adjust an image in a series of small steps (minimal adjustments) as the effects are cumulative.

Note: Drastic increases and/or decreases in high-contrast areas can result in chromatic aberration, also known as red/cyan color fringing. This can be addressed in most RAW processing programs.

So this is my basic HDR workflow using Photomatix Pro. You will see in the following pages the use of various other processing and software optimazation techniques, and some more creative techniques applied to HDR images. We will go from the natural look to ever increasingly optimized and interpretive renderings. The important thing is to try everything you can think of. This will expand the parameters of what you think is possible, and may even profoundly change your approach to image making. Please bear in mind that no matter what you try or how far out the image gets . . . nobody gets hurt!

Postprocessing Techniques

Even after creating your final compiled HDR image in Photomatix, you will need to do more postprocessing. It's common knowledge among HDR shooters that no matter what you do in Photomatix, the resulting image is flat. All the detail is there, which is the ultimate point, but we need to increase contrast. Here are three ways to increase contrast, creating an image with more depth and visual punch.

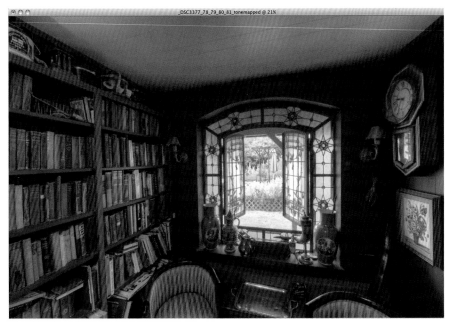

Figure 1

This image (Figure 1) is adjusted as much as possible to taste in Photomatix only. No other postprocessing software was used.

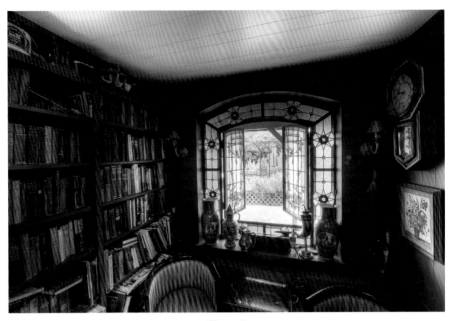

Figure 2

Figure 2 has a contrast curve applied in Photoshop. This does add a little punch and is a good and free way (if you own photoshop) to increase the visual impact of a Photomatix-processed image.

In the Curve Adjustment box in the Curves dropdown menu at the top of the window, there are several contrast options: Increase Contrast, Linear Contrast, Medium Contrast, and Strong Contrast. None of these exactly worked for me, so I just made my own small "s" contrast curve.

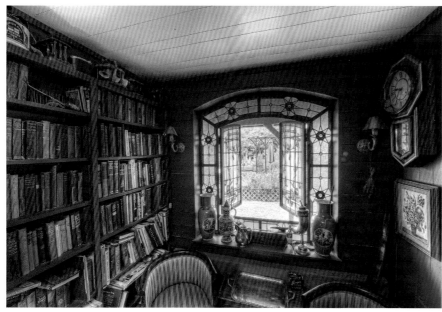

Figure 3

This image was optimized using NikSoftware's Tonal Contrast, from the Color Efex 3 set of filters. I made only minor adjustments in the controls in the right column. I decreased shadow contrast and increased Midtone contrast to taste.

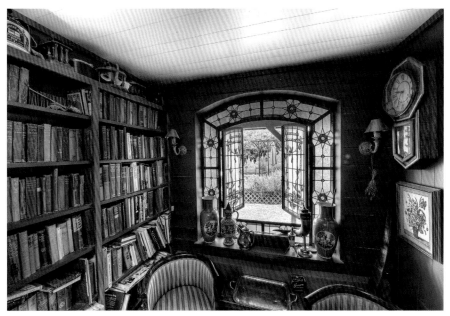

Figure 4

This final image is optimized using LucisPro. For HDR images, after a bit of experimentation, I begin with my presets. For what I'm looking for, these numbers work well as a jumping-off point.

As you can see from these image illustrations, the final rendering can change quite dramatically based on software choice, experimentation, personal vision, and specific settings. And, of course, we can't disregard budget and personal priorities in purchasing software. Professional imaging software and plugins are very advanced and worth the price in most cases. Although I use all the plugins mentioned in this book in my professional workflow, you will notice that some appear more frequently than others. This is personal preference and gives me what I'm looking for.

The ideas and techniques given here are a good jumping-off point, but don't be shy about trying other things, perhaps not in this book, to realize the image you see in your imagination. The most important thing to bear in mind is that there are no rules; so try everything, have fun, and no matter what you do, no one gets hurt!

Page Layout

Since the up-front work in this book laid out the basic workflow and explained each setting box in Photomatix, this will not be repeated throughout the book. Instead, I will list and discuss the settings used for each photo that deviated from the default settings and why those particular settings were used. There are certain combinations that work and some adjustment compensations based on other adjustments. This is confusing for many beginning and even advanced HDR photographers. This will also be mentioned in the "Settings" box.

It's important to note that even though one can fully bring in all the details throughout an image, the resulting image can appear flat, as in a poorly optimized shadow/highlight command in photoshop. Controlling highlights and shadows to manage detail and to create a sense of depth and realism is a practical use for HDR photography. Of course, we'll get into more surreal, over-the-top processing later in the book.

Things to keep in mind:

- A multiple-image approach on non-hdr situations, where the entire dynamic range can be captured using one exposure, can still take on an HDR look through tone mapping. However, achieving a tone mapped look with a single properly exposed image may be better rendered using Topaz Adjust or Nik's HDR Efex Pro.

- Textured cloud: Gray, almost stormy clouds with detail are great for HDR renderings.

- Shooting indoors and wanting detail outside will require many exposures on the underexposure side, up to −5EV.

- Shooting high-contrast scenes: Bright, sunny days are made for HDR shooting, but reds can be a little tough to render in Photomatix because of the inherent issues with the red spectrum in digital photography. Slightly desaturating can help to tone down puddled reds. Nik's HDR Efex Pro can handle "hot" reds well.

- HDR is a viable option when it's impossible to use a split grad ND filter—for instance, using a superwide 14mm FX lens with a bubble front element makes it impossible to use a split grad neutral density to hold back highlights.

- Software and processing techniques are always evolving for the better, so it's a good practice to go back to favorite HDR images and reprocess them again when a new software or software update are released.

- HDR in nature: It can be accomplished, but care should be taken to use minimal processing to avoid the grunge look, which in nature may appear unnatural and visually distracting.

- Postprocessing is essential in most images. Many, if not most, images processed in Photomatix, with the exception of grunge processing, will need further processing in image editing software to enhance the image. Also, always process using small moves and increase incrementally. Less postprocessing appears to be needed when using HDR Efex Pro.

- Software previsualization: One is always encouraged to play in software-land. As you work with software more and more, you'll begin to previsualize the final effect of particular software techniques and plugins on the final image.

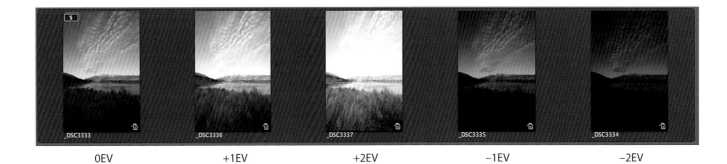

| 0EV | +1EV | +2EV | −1EV | −2EV |

Dawn Lake

Sundance, UT

Settings

Strength: Default is 70. Set to 80 to accentuate cloud detail.
Color Saturation: Default is 46. Set to 70 to bring out color in the distant mountains and
 to deepen the sky color.
Luminosity: Default is 0. Set to 5.8 to add brightness and detail.
Smoothing: Set to High (personal preference).
White Point and Black Point: Both set to .10 for minimal working contrast.
Gamma: Default is 1.0. Set to .8 to globally darken the image.

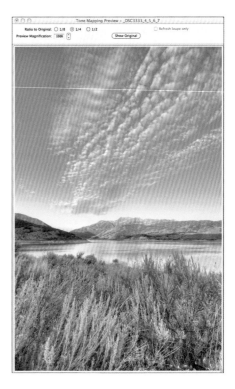

My first impulse was to use a Singh Ray split neutral density filter, forgetting for the moment that I was using a 14mm lens with a bubble front element. This necessitated the use of high dynamic range photography. After compiling the images, and selecting Tone Mapping, the next thing I do in the Tone Mapping box is to press the Default button at the bottom of the box. This will give what Photomatix "thinks" is natural. The Default setting is good for rendering a natural look to your image, but even when not using HDR at all, you still will need to do a little tweaking, such as adding saturation and contrast. The adjusted image on the opposite page is the scene slightly optimized to create a greater sense of depth and look more as it appeared (by slightly increasing contrast in the foreground grasses using Nik's Viveza).

Surprisingly, most of the time, the Default setting is a pretty good jumping-off point and it will take minimal processing outside of Photomatix to attain a natural HDR look, which I prefer for nature photography most of the time. But there are exceptions, which we will illustrate and discuss in later images.

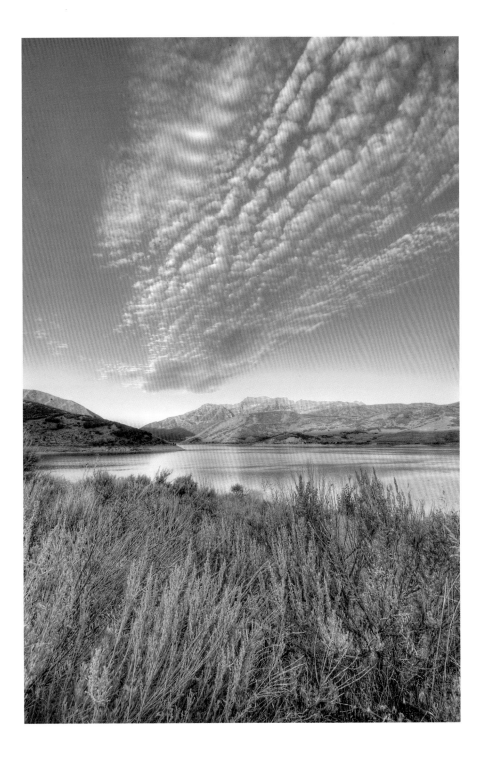

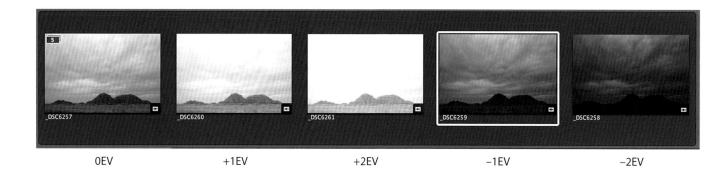

| 0EV | +1EV | +2EV | −1EV | −2EV |

Storm Clouds

Badlands National Park, SD

Settings

Strength: Default is 70. Set to 80 to accentuate cloud detail.
Color Saturation: Default is 46. Set to 60 to bring out color in the foreground.
Luminosity: Default is 0. Set to 3.8 adds brightness and detail.
Smoothing: Set to High (to taste).
White Point and Black Point: Both set to .10 for minimal working contrast.
Gamma: Default is 1.0. Set to .8 to globally darken the image.

This is very straightforward standard HDR image (five-exposure series with Auto Exposure Bracketing in Nikon; three-exposure series, −2EV/0EV/ −2EV in Canon). As you can also see from the series, none of the images work by themselves. Neither the sky nor the grasses and hills are properly exposed. The five-image auto bracketed series brought in all the highlights and shadows, enabling me to add some drama to the clouds (using the strength setting) and to add contrast and detail to the foreground. The image at the Default setting (left) was slightly washed out, but adjusting using the aforementioned settings fixed this (opposite page).

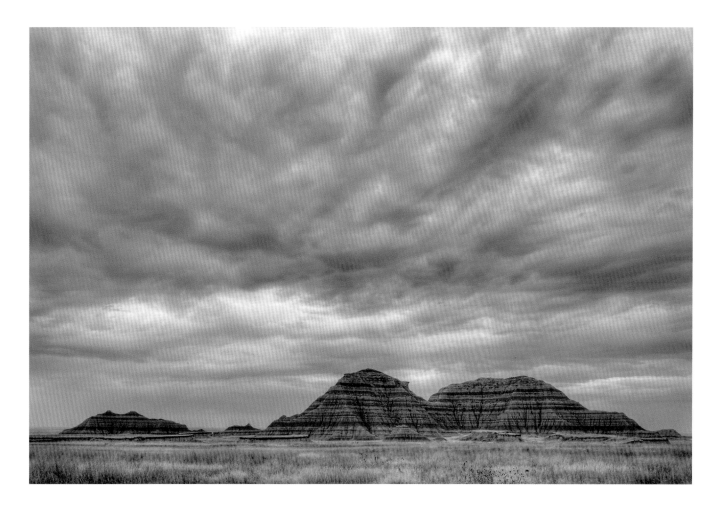

0EV	+1EV	+2EV	−2EV
_DSC7621	_DSC7623	_DSC7624	_DSC7622

Hidden Pond

Kancamagus Pass, NH

Settings

Color Saturation: Default is 46. Set to 100, unusually high for me, but necessary to beef up this flat scene.

Luminosity: Default is 0. Set to 10, again unusually high, but adds brightness and detail.

Smoothing: Set to High (to taste).

White Point and Black Point: Both set at .072, or at the third mark on the scale, to increase contrast.

Temperature: increased to +6.0 to add warmth to the scene.

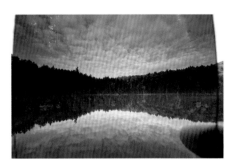

I could have used a Singh Ray hard edge split graduate neutral density filter her; however, this image was shot with a true 14–24mm wide angle zoom. Coverage was impossible, necessitating the use of an HDR sequence.

The processed image, to the left, is quite dark at the bottom. I used a layer of LucisPro to increase contrast and to enhance detail; I also used Nik's Viveza photoshop plugin to selectively lighten the bottom of the frame. One could also select the area, feather to about 35, and perform a curve adjustment layer to lighten the area. With moving clouds, it's critical to shoot faster exposures to avoid or minimize cloud "ribbing," where you see multiple iterations of the clouds as they move through each exposure. The final output image illustrates these changes.

Tone Mapping Preview – _DSC7621_2_3_4

Ratio to Original: ○ 1/8 ● 1/4 ○ 1/2 ☐ Refresh loupe only
Preview Magnification: 100% (Show Original)

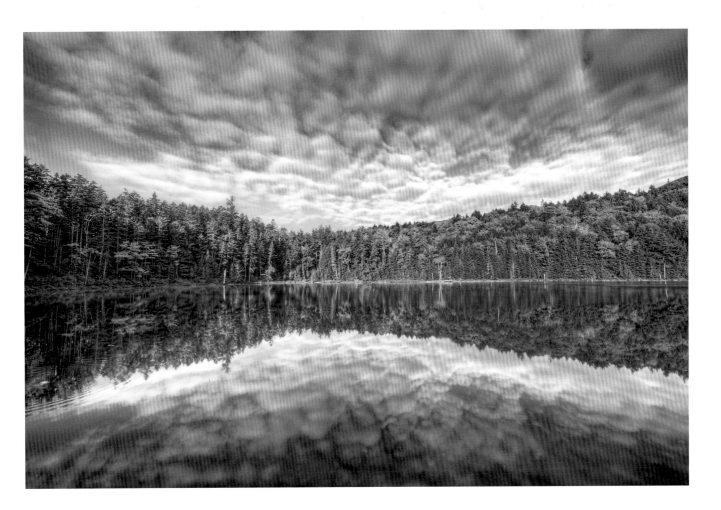

_DSC3321	_DSC3322	_DSC3323	_DSC3324	_DSC3325
0EV	−2EV	−1EV	+1EV	+2EV

Coupeville Wharf at Sunset

Coupeville, WA

Settings

Strength: Default is 70. Set to 66 to avoid small dark patches on the boardwalk.
Luminosity: Default is 0. Set to +6.2 to dramatically brighten the image.
Microcontrast: Default is 0. Set to 2 to balance the bright luminosity setting.
Highlight Smoothness: Default is 0. Set all the way to 100 to pull all grain out of the sky.

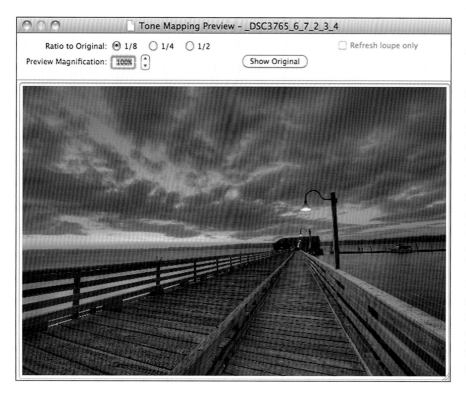

After taking the standard five-exposure HDR sequence and checking the histogram, I still saw clipping at the highlights. This necessitated one more underexposure to −3, which brought in all of the highlights. But there are still a couple of issues. The horizon line is tilted, which is an easy fix using the ruler tool in Photoshop. But more importantly, the image lacks clarity. This is normal for HDR compilations in Photomatix. Increasing contrast/microcontrast in Photomatix is not enough and microcontrast, which is good for creating the "grunge look," adds a tremendous amount of noise to the sky and creates dark patches in the sky and clouds. However, there are several other options. One can create a contrast curve on an adjustment layer in photoshop/elements; one can employ Nik Software's Color Efex Pro Tonal Contrast filter; or one can use my software of choice (though not inexpensive), Lucis Pro. It's important to make sure that whichever option you choose is on a separate layer so that you can blend the original and the adjustment layer to taste.

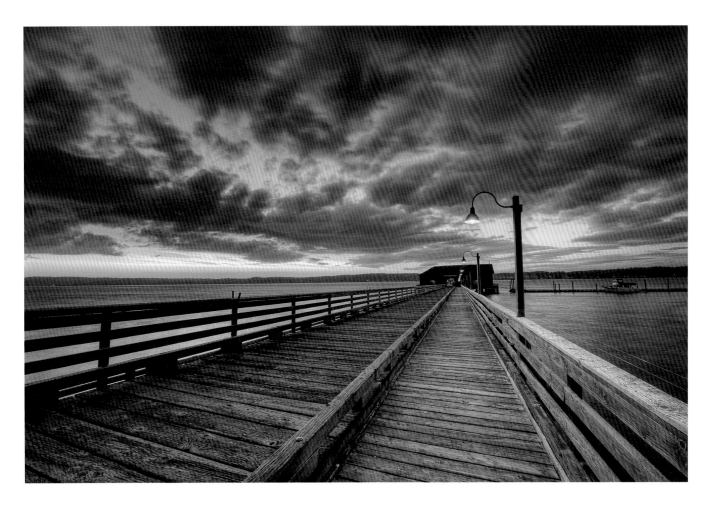

_DSC0752.NEF	_DSC0755.NEF	_DSC0756.NEF	_DSC0754.NEF	_DSC0753.NEF	_DSC0757.NEF	_DSC0758.NEF
0EV	−2EV	−1EV	+1EV	+2EV	−3EV	−4EV

Tunnel

Ft. McHenry, MD

Settings

Saturation: Default is 70. Set to 100 to add color to a very drab scene.

Luminosity: Default is 0. Set to 10 to futher brighten the image and tone down chromatic aberration.

Microcontrast: Default is 0. Set to 6 to bring out the texture in the bricks and to slightly darken the image.

Smoothing: Set to High (to taste).

Black point: Set to .060.

White Point: Set to .020 to darken the inside of the tunnel.

Gamma: Default is 1.0. Set to 1.2 to globally brighten the image.

Micro-smoothing: Default is 9.0. Set to 3.3 to increase detail in the clouds and in the bricks.

Highlight Smoothness: Default is 0. Increased to 20 to remove grain from the sky/clouds.

The Photomatix final process got this in the ballpark, but needed more. Again, as with all Photomatix HDR output, more contrast had to be added in post-processing. In this case, I chose to use Nik Color Efex Pro Tonal Contrast filter, which gave me the ability to to lower shadow contrast slightly to tone down the noise, then slightly increase saturation to bring out the red tonality in the bricks. Leaving the highlight contrast set to the default increased detail in the clouds. However, when very bright areas meet very dark areas, you have chromatic aberration. If you look very closely at the opening, you'll see a small red outline. That's chromatic aberration. Even though there are adjustments for this problem in Photomatix, Adobe Camera Raw (ACR), Aperture, and Lightroom, they may not remove all of the chromatic aberration in most images. You will probably need to go in and manually clone out the rest of red (or cyan) fringing, which I did in the final image on the right. The cloning process took about fifteen minutes.

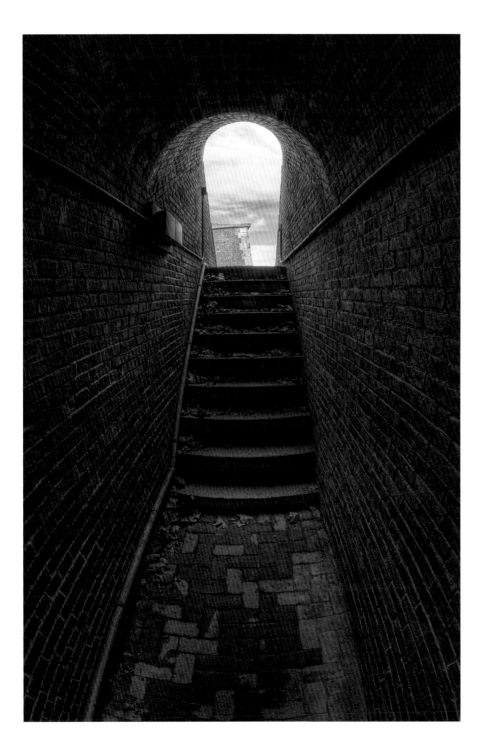

Version Name: _DSC1822	Version Name: _DSC1823	Version Name: _DSC1824	Version Name: _DSC1825	Version Name: _DSC1826
0EV	−2EV	−1EV	+1EV	+2EV

Old Barn

Delaware Water Gap, PA

Settings

Saturation: Default is 46. Set to 79 to intensify overall color.

Luminosity: Default is 0. Set to 10 to futher brighten the image and tone down chromatic aberration.

Microcontrast: Default is 0. Set to 4 to bring out the texture in the barn and to slightly darken the image.

Smoothing: Set to Mid (to taste).

Black point and White Point: Set to .020, which is a normal first adjustment to create working contrast.

Gamma: Default is 1.0. Set to .85 to to globally darken the image compensating for the high luminosity setting.

All other settings kept at default.

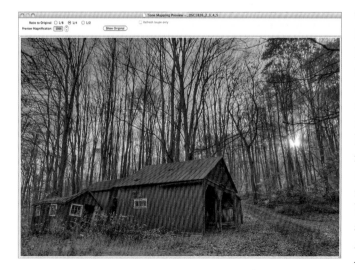

What I found the most interesting in this image is the fact that only five images were required to get all the highlight and shadow detail. This was probably because there was a forest of leafless trees blocking direct light from the sun. You'll also notice that there is a bit more detail in the barn and an overall crisper look to this image, which is the result of applying Nik's Color Efex Pro Tonal Contrast filter. It also helped that I only minimally altered the the default settings, lowering shadow contrast to take some of the edge off and lowering saturation, as the barn came in with the reds punched up a bit too much. The HDR effect is apparent where you can see all the detail inside the barn and adjacent buildings. As you can see from the initial five-image sequence, the −1EV image rendered the best sky, resulting in the barn being barely visible. The final output was almost exactly how it looked in reality.

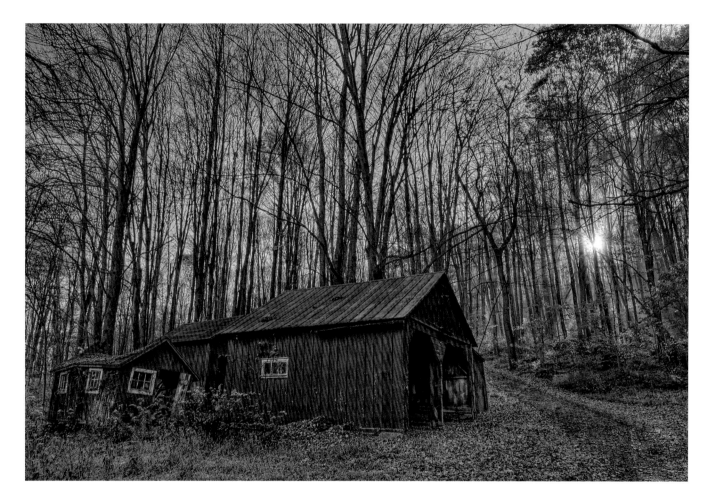

| +1EV | 0EV | −1EV | −2EV |

Morning Scenic

Badlands National Park, SD

Settings

Strength: Default is 70. Set to 41 to eliminate dark patching, which is always an issue when doing HDR with clear blue skies.

Luminosity: Default is 0. Set to 6 to futher brighten the image and tone down chromatic aberration.

Microcontrast: Default is 0. Set to 4 to bring out the texture in the foreground and to slightly darken the image.

Smoothing: Set to Mid (to taste).

Black point: Set to 1.85.

White Point: Set to .18, in order to increase contrast and to create shadows in the foreground.

Gamma: Default is 1.0. Set to 1.2 to globally brighten the image.

All other settings kept at default.

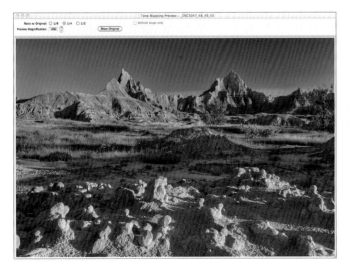

The final Photomatix output was a bit cool for my taste, and flat. I used the Nik's Viveza and only did the following global adjustments: I increased contrast, which deepened the shadows; increased structure, which enhanced detail; and moved the white balance to the warm side to give the appearance of early morning light, though this scene was actually photographed in late morning. The beauty of Viveza is the ability to adjust many settings in one pass. For example, after selecting a control point, we can adjust brightness, contrast, saturation, structure, shadow, warmth (white balance), red, green, blue, and hue all at once. These adjustments can be made on selective control points for targeted adjustments or globally, as in this image.

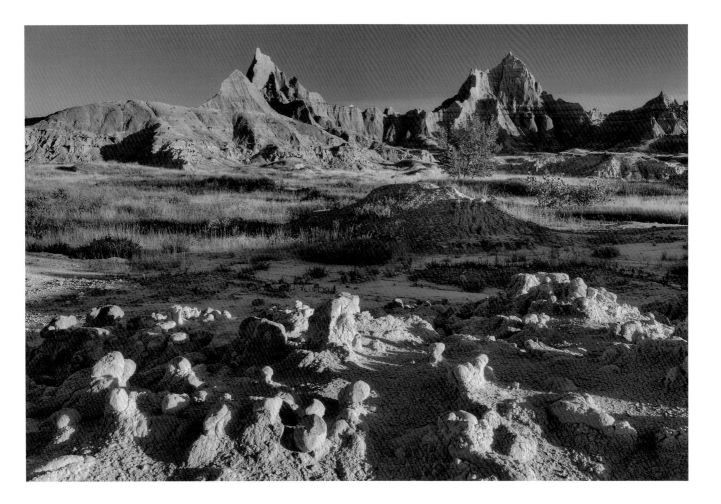

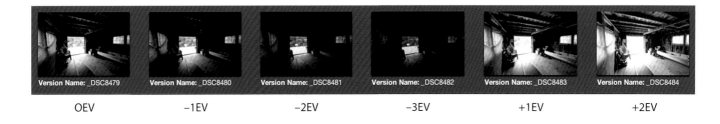

Version Name: _DSC8479	Version Name: _DSC8480	Version Name: _DSC8481	Version Name: _DSC8482	Version Name: _DSC8483	Version Name: _DSC8484
0EV	−1EV	−2EV	−3EV	+1EV	+2EV

Back Cove

New Harbor, ME

Settings

Strength: Default is 70. Set to 81 to taste. The effect was to darken the inside, drawing attention to the opening.

Luminosity: Default is 0. Set to 6 to futher brighten the image and tone down chromatic aberration.

Microcontrast: Default is 0. Set to 4 to bring out the texture in the foreground and to slightly darken the image.

Smoothing: Set to Mid (to taste).

Black point and White point: Set to .062 to slightly increase contrast.

Temperature: Default is 0. Set to −6.0 to create a cooler color palette

All other settings kept at default.

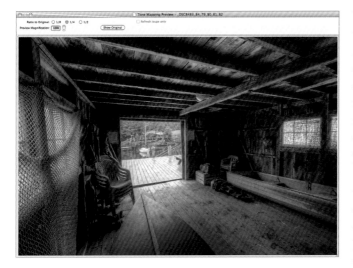

This is a classic HDR situation. Many of you will know that typically, when this type of scene is exposed for the inside, the outside is completely blown out. If it were exposed for the outside, which we would never do in one exposure, the inside would be almost black. Notice the difference between the soft, low-contrast Photomatix rendering and the final shot at the right. This is the result of optimizing with LucisPro. This software is a photoshop plugin, originally designed to enhance detail in X-rays. LucisPro is quite expensive, but it is remarkable in how it enhances detail in the red, green, and blue channels. The almost tactile depth of field is the result of how Lucis affects an image, particularly the contrast ratio between pixels. When you select the high strength setting, the eye quickly goes through the boat house to the sailboat in the harbor. Also, the use of a 14mm wide angle exaggerated the perspective lines, further pulling the eye through the frame.

Note: Photomatix can render whites as greys or blacks in extreme cases. I let the white plastic chairs to go gray so as to not influence the eye as it travels through the opening.

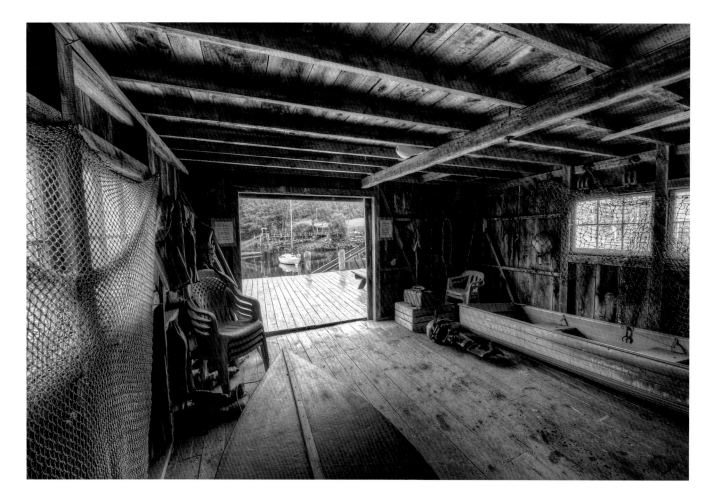

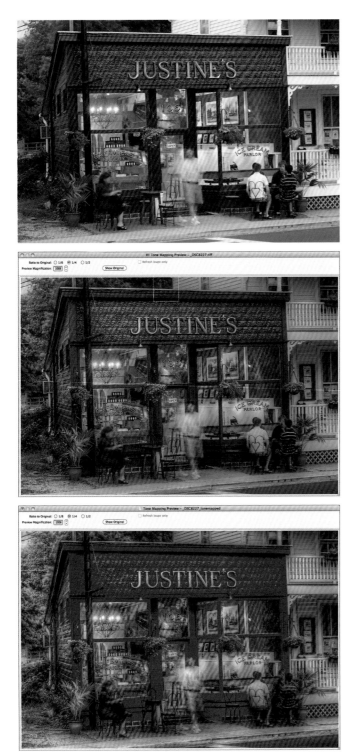

Justine's

St. Michaels, MD

Every so often you'll capture a single image that you may think would look good tone mapped even though it is not an HDR series. Or perhaps there's some movement (as in this image) that precludes a multiple-image approach. The easiest way to tone map a single image in Photomatix is to simply drag and drop a 16-bit tiff or RAW file onto the Photomatix application icon. The image will open, along with the Tone Mapping Settings box. More often than not a single image with one tone mapping will not render a dramatic enough change. Therefore, I'll almost always double tone map a single image to go for a grittier look.

After the top image opened, I set the black and white points to .010, then maxed out the following settings: Strength=100; Color saturation (normally 100) pulled back to 86 to control the red puddles of color that can occur; Luminosity=10; and Microcontrast=10. Then I pressed "Process."

The middle image is the result of the first tone map. For the second tone map, simply press the "process" button a second time. This will double the effect of the first tone mapping, illustrated in the botton image. All the grit is in there. It's just hidden under the puddles of red color.

The final image on the opposite page was the result of these final adjustments: I pulled back the strength to 41 to lighten the top of the image and remove dark patches, which can result from the strength being set too high. The most dramatic change occured when I pulled the saturation from 86 to 30, rendering an image very close to the final output image. Since light colors can be negatively affected during the HDR process, I moved the Highlights Smoothing from 0 to 62, which kept the bright colors looking bright, rather than "dirty." In this image, the "Justine's" sign became a bit dull, so it was brightened up at the end of the process using Nik's Viveza software.

Double-processed images made in this fashion, with the microcontrast set high for both processes, can get quite grainy or noisy. If it's a bit much, noise reduction software can be used to remove some of the effect.

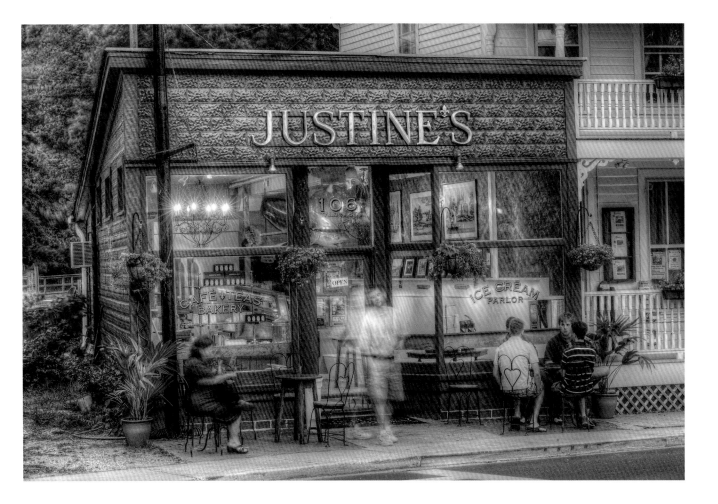

| 0EV | −2EV | −1EV | +1EV | +2EV |

Working Boat

Cape May, NJ

Settings

Strength: Default is 70. Set to 38 for a natural sky and clouds. High Strength settings create dark patching in the sky.

Saturation: Default is 46. Set to 100, as the scene was in very flat light with dull color.

Luminosity: Default is 0. Set to 10. Together with the Saturation setting, this increased overall brilliance.

Smoothing: Set to High (to taste).

Black point and White point: Set to .060 to slightly increase contrast.

Micro-smoothing: Default is 9. Set to 2 to bring in some cloud texture.

All other settings kept at default.

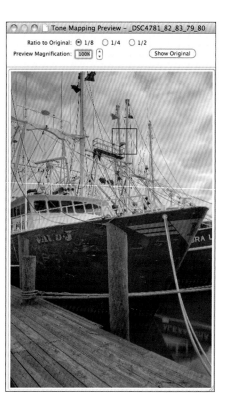

This image was made late in the afternoon. Aside from good cloud detail, which we refer to as HDR clouds, the light was very flat and the color totally lacked punch. The light and color were brought out to a degree in Photomatix, using the aforementioned settings. The multiple-image approach (HDR) brought out details in the undersides of the boats and captured all cloud detail. In addition to the HDR process in Photomatix, a layer of Lucis-Pro was applied to enhance detail, and I applied Nik's Color Efex Pro Contrast Color Range filter for the last enhancement to increase contrast and saturation in the hulls of the boats.

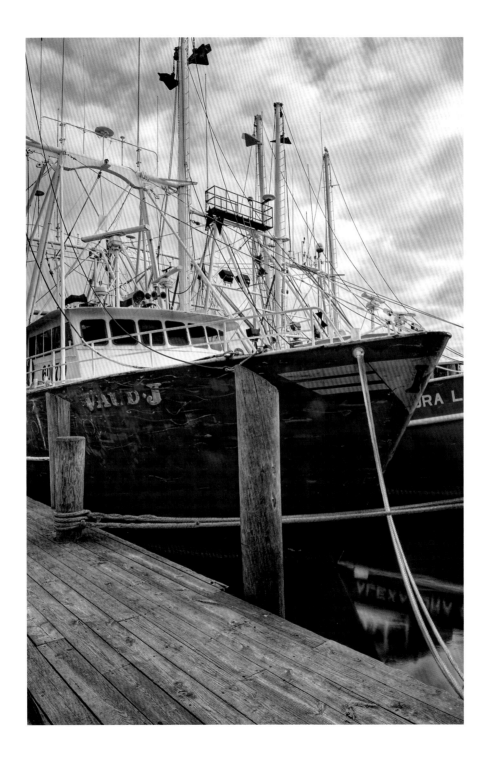

| 0EV | −2EV | −1EV | +1EV | +2EV |

Old Car and Cloud Reflection

Car Farm, Hood, VA

Settings

Saturation: Default is 46. Set to 100 as the scene was in very flat light with dull color.
Luminosity: Default is 0. Set to 10. Together with Saturation, this setting increased overall brilliance.
Smoothing: Set to High (to taste).
Black point and White point: Set to .010 to establish pure white and pure black (minimal contrast).
Micro-smoothing: Default is 9. Set to 6 to enhance detail and texture.
All other settings kept at default.

Old cars are great grist for HDR photography and with this one I had the bonus of a great sky of HDR clouds. The Photomatix processing could have been all I needed on this image, which is unusual, but there were some targeted adjustments that I felt were needed. Using Nik's Viveza, I slightly desaturated the entire scene (global adjustment). I selected the cars and increased structure and contrast (selective adjustment), and selected and lightened up the rear underside of the car. I also used four small control points to increase structure in the back window to bring out the reflection a bit more.

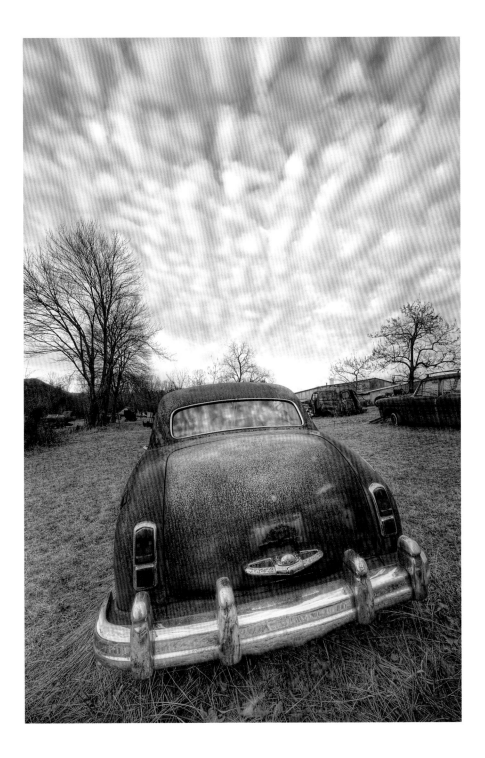

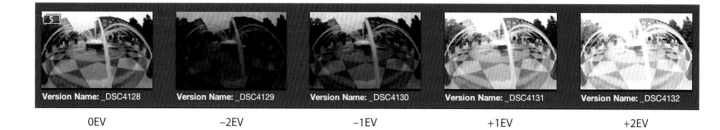

| 0EV | −2EV | −1EV | +1EV | +2EV |

Fountain

Charleston, SC

Settings

Strength: Default is 70. Set to 91 (to taste).

Saturation: Default is 46. Set to 91 as the scene was in very flat light with dull color.

Luminosity: Default is 0. Set to 8.5. Together with Saturation, this increased overall color, but still left it a bit dull.

Microcontrast: Default is 0. Set to 1.9 to add detail.

Smoothing: Set to High (to taste).

White point: Set to .010.

Black point: Set to .250 to increase contrast.

Micro-smoothing: Default is 9. Set to 6 to enhance detail and texture.

Gamma: Default is 1.0. Set to .842 to slightly darken the image.

Micro-smoothing: Default is 9.0. Set to 6.8 (lower) enhances detail

Highlights Smoothness: Default is 0. Set to 19 to tone down grain in the clouds.

All other settings kept at default.

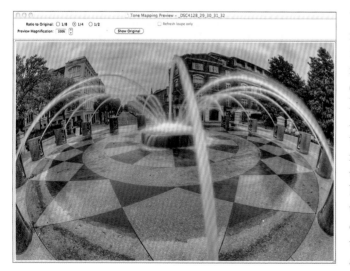

This was a very difficult image to optimize. Normally, my adjustments in Photomatix are minimal, but this image was so flat that even with an active list of adjustments in Photomatix, listed above, the processed image (shown in the small window at left) needed more work. I added a layer of LucisPro to further enhance the image. Afterwards, I used a series of adjustments in Nik's Viveza to arrive at the final image. First I increased global brightness and contrast. Then I made a series of targeted selective adjustments: I brightened the center of the fountain; brightened the tops of the trees on the right; brightened the top of the red building (the high strength setting had created a dark patch); added wamth to the building on the right; brightened the street going into the distance; and brightened the palm trees lining the street.

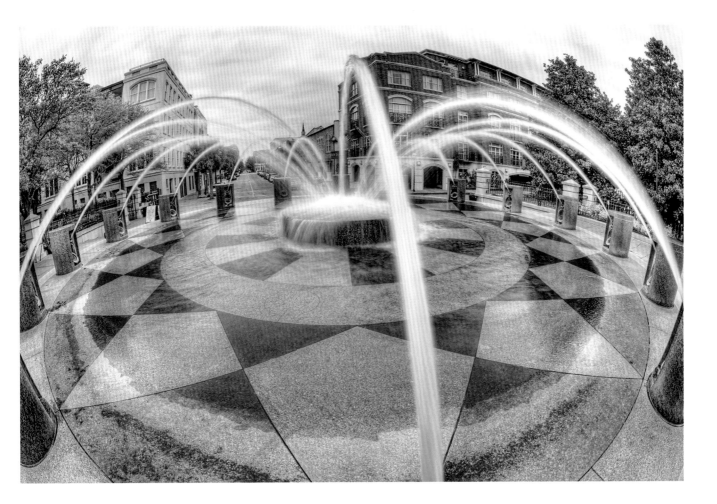

| 0EV | −1EV | −2EV | +1EV | +2EV |

Old Barn

Delaware Water Gap, PA

Settings

Saturation: Default is 46. Set to 100. With infrared, this has the effect of slightly darkening the image and increasing contrast.

Luminosity: Default is 0. Set to 10 to lighten image image to taste

Smoothing: Set to Low.

White point: Default is .25. Set to .6 to increase white in infrared.

Black point: Default is 0. Set to .012 to add some pure black.

Micro-smoothing: Default is 9. Set to 6 to enhance detail and texture.

Gamma: Default is 1.0. Set to .842 to slightly darken the image.

All other settings kept at default.

What's interesting about this HDR set is how dark the image has to get to keep detail in the very bright foliage.

The situation was one where the sun was extremely bright and contrasty and the barn facing the camera was in deep shade, necessitating a multiple-image approach. I could probably have gotten by with three exposures (0EV, −2EV, +2EV); I think using all five images increased the dynamic range, but opinions will vary about this.

I use the Low Smoothing setting rarely; it results in a very flat image. This was done with postprocessing in mind. Nik's Glamour Glow filter is great for infrared, creating a soft, overprocessed glow, but it smooths out detail. The Low Smoothing setting exaggerated the detail, making the image appear slightly oversharpened. After the Glamour Glow filter was applied, the oversharp look was smoothed out, retaining the detail in the wood and trees.

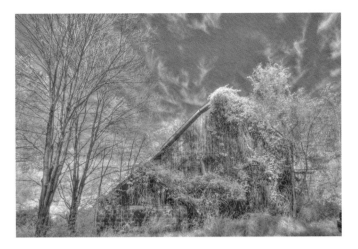

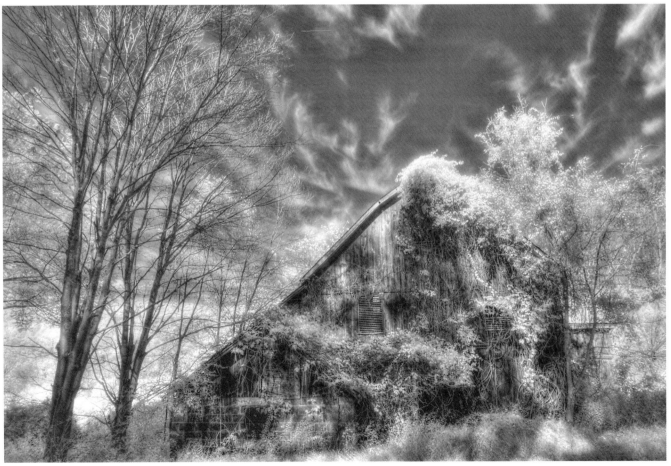

Version Name: _DSC0253 | Version Name: _DSC0254 | Version Name: _DSC0255 | Version Name: _DSC0256 | Version Name: _DSC0257

0EV −2EV −1EV +1EV +2EV

Rawlings Conservatory

Baltimore, MD

Settings

Strength: Default is 70. Set to 81 to increase cloud detail.

Saturation: Default is 46. Set to 79 (to taste).

Luminosity: Default is 0. Set to 10 to lighten image image to taste.

Smoothing: Set to High (to taste).

White point: Default is .25. Set to .126 to increase brightness.

Black point: Default is 0. Set to .052 to add some pure black and to add contrast.

Highlights Smoothness: Default is 0. Set to 9 to reduce grain in the sky.

All other settings kept at default.

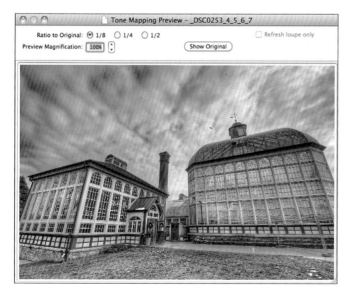

After processing the HDR sequence, Nik's Viveza was used in postprocessing to increase contrast, lower saturation, and to increase structure (detail). The full-frame 14mm pointed upwards to get this composition. The keystoning is distracting, but can easily be fixed using the perspective crop tool in Photoshop. After you draw the crop line around the entire image, the menu changes to the tool strip. At this time and here only, you can check "perspective," (CS4) enabling you crop using each individual handle around the selection. Holding down the shift key will move the line on a horizontal axis, creating the image at the top of the next page. After you press "return," the crop is completed and the stretched image is the result. This works well here, but may not work as well on all images, as it can create too much distortion.

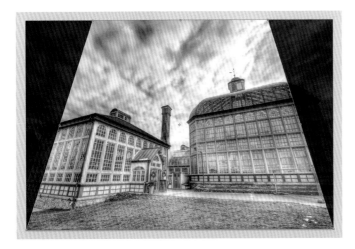

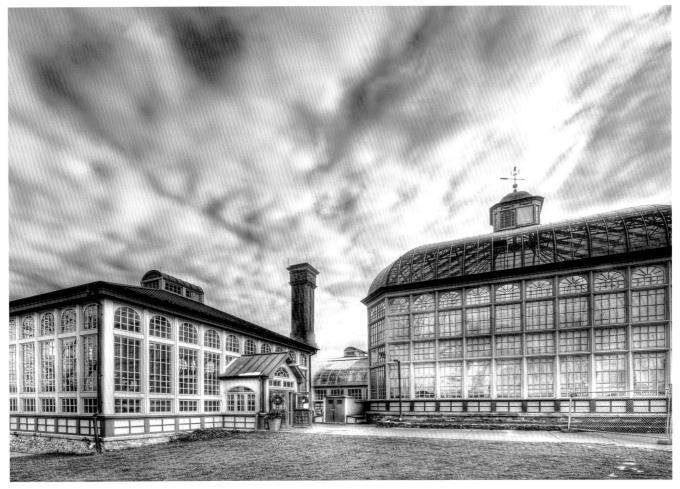

| OEV | −2EV | −1EV | +1EV | +2EV |

Door and Windows Trail

Badlands National Park, SD

Settings

Strength: Default is 70. Set to 50 to reduce dark patches in the sky.

Saturation: Default is 46. Set to 79 (to taste).

Luminosity: Default is 0. Set to 10 to lighten image image to taste.

Smoothing: Set to High (to taste).

White point: Default is .25. Set to .126 to increase brightness.

Black point: Default is 0. Set to 7.241 (very high) to darken the underside of the shelf.

Highlights Smoothness: Default is 0. Set to 59 to reduce grain in the sky.

All other settings kept at default.

This image of the South Dakota Badlands was shot in late morning, which out there can be as early as 6:00, and the scene was almost evenly lit with the exception of the frontmost bottom right corner, which was much darker. In order to increase contrast in the formations, get a deeper blue sky, and bring in the lower right foreground area that was facing away from the light, I shot a five-image HDR. Having the entire dynamic range gave me more control over color and contrast. Additional global and targeted color contrast was added using Nik's Color Efex Pro color contrast range filter.

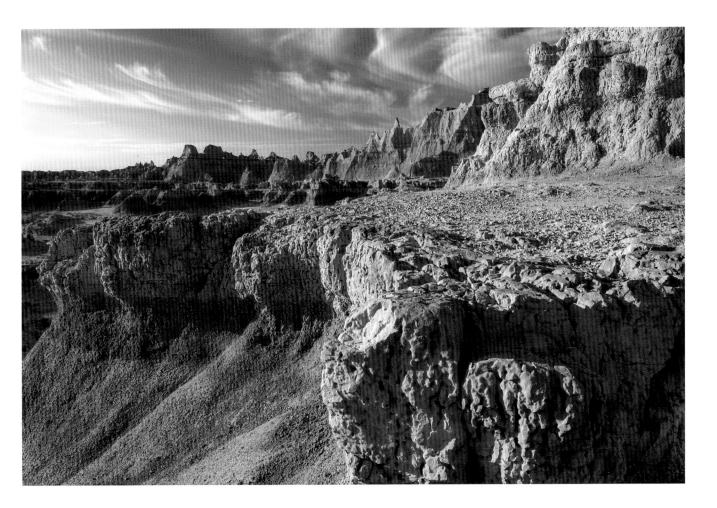

Version Name: _DSC4023	Version Name: _DSC4024	Version Name: _DSC4025	Version Name: _DSC4026	Version Name: _DSC4027
0EV	−1EV	−2EV	+1EV	+2EV

Plowed Fields and Rapeseed Hills

Colfax, WA

Settings

Saturation: Default is 46. Set to 78 (to taste).
Luminosity: Default is 0. Set to 5.6 to lighten image image to taste.
Smoothing: Set to High (to taste).
White point and Black point: Set to .6 to globally increase contrast in Photomatix.
Gamma: Default is 1.0. Set to .833 to slightly darken the image.
All other settings kept at default.

The flat processed HDR image, which needs more work, is below. I tend to use Photoshop to increase contrast on Photomatix HDR images. The top image on the opposite page is optimized using Nik's Color Efex Pro contrast color range filter to slightly increase contrast and to increase global saturation. I then used Nik's Viveza to brighten and add contrast to the structures, then Photoshop's hue and saturation tool to slightly desaturate the hay field.

To finish off the image, I chose to use Topaz Adjust. Adusting the Exposure and Regions tabs created more contrast in the clouds and plow rows. Then I selected the Detail tab and turned down Strength and Boost to soften the detail, creating a slightly super-real, more painterly image. Finally, I targeted the hills using Viveza to brighten the dark areas. This much activity is about normal for my processing workflow.

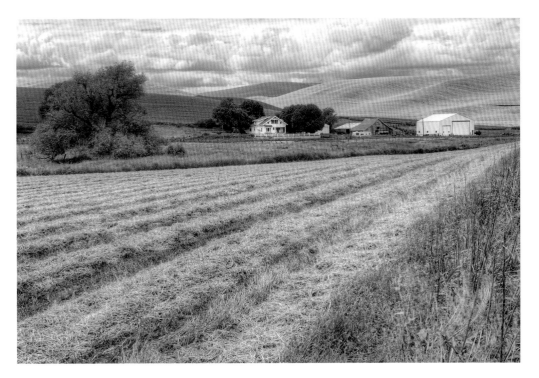

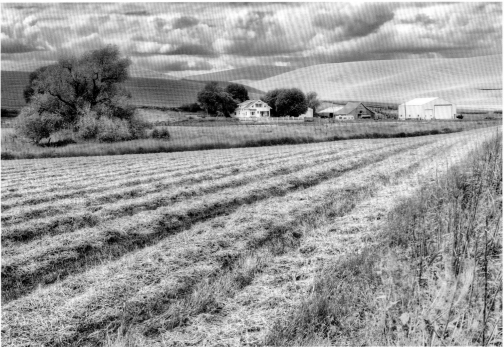

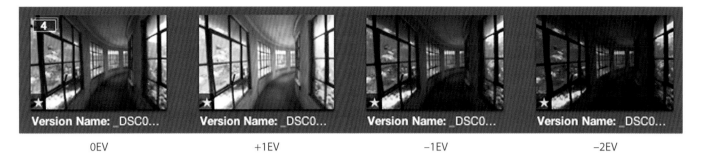

| 0EV | +1EV | −1EV | −2EV |

Corridor

Ellis Island, NY

Settings

Strength: Default is 70. Set to 100 (to taste).

Color Saturation: Default is 46. Set to 51 (to taste).

Luminosity: Default is 0. Set to 8 to lighten image to taste.

Microcontrast: Default is 0. Set to 4.2 to increase detail and texture.

Smoothing: Set to Mid (to taste).

White point and Black point: Set to .010 to establish pure white and pure black (minimal contrast).

Gamma: Default is 1.0. Set to .833 to slightly darken the image.

All other settings kept at default.

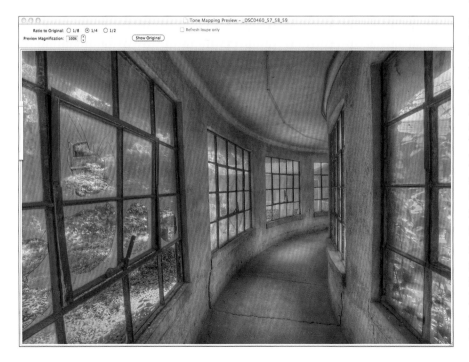

My friend Mark Menditto and I were quite fortunate to get into the closed-off parts of Ellis Island to shoot HDR for two days. The event was memorable to say the least. Notice the green cast in the hallway in the bottom image. This is the same thing as a green cast under a canopy in the forest on a bright sunny day. The bright green foliage is reflected into the hallway by the very bright sun. This is how it looked, but I'd like to tone that down. The top image on the right was processed using Lucis-Pro, which toned the color down, based on my presets; also, contrast was increased and detail was enhanced. However, you can also accomplish close to the same effect using Nik's Tonal Contrast filter in Color Efex Pro. The bottom image on the opposite page uses Nik's Darken/Lighten Center filter from the Color Efex Pro filter set. Both images work; however, the feel is quite different. In the top image on the opposite page, the eye tries to take in the entire image, looking side to side and down the hallway. In the bottom image, the eye is immediately pulled down the hallway to the back of the image.

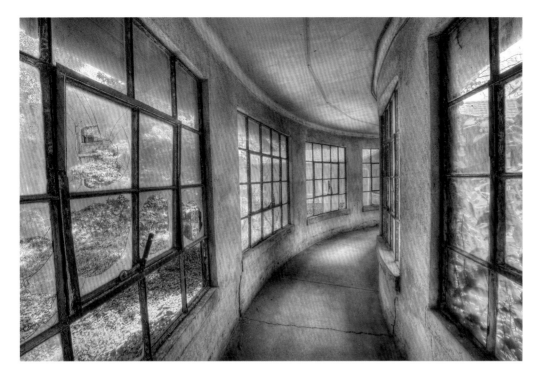
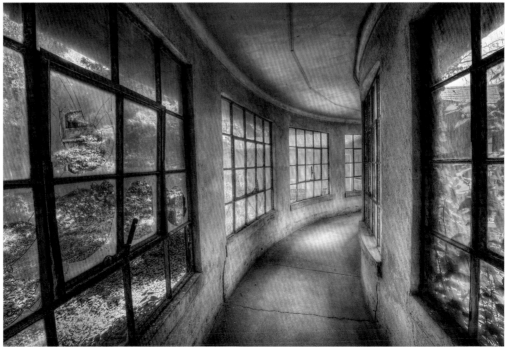

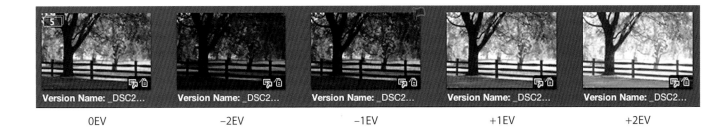

| 0EV | −2EV | −1EV | +1EV | +2EV |

Fall Fence Line

Worthington Valley, MD

Settings

Color Saturation: Default is 46. Set to 60 (to taste).
Luminosity: Default is 0. Set to 4.5 to lighten image to taste.
Microcontrast: Default is 0. Set to 4.1 to increase detail and texture.
Smoothing: Set to Mid (to taste).
White Point: Default is .250. Set to .143 to slightly darken the image.
Black point: Default is 0. Set to .006 to increase contrast.
Gamma: Default is 1.0 Set to .833 to slightly darken the image.
All other settings kept at default.

This image had good strong backlight through the color and needed a multiple exposure approach (HDR) to get all the detail. As you can see in the bottom image, there is a little detail in the tree trunk and a blue sky, so the blown-out areas and the very dark areas are being rendered nicely. But to add some depth to the image, I selected Nik's contrast color range filter (CEP). I then created a mask on the color contrast range layer, and painted in only the reds on the original to create depth by separating the foregound tree from the background. After this, I opened up the dark patches, apparent in the upper right side of the smaller preview image, using Nik's Viveza to brighten those targeted areas.

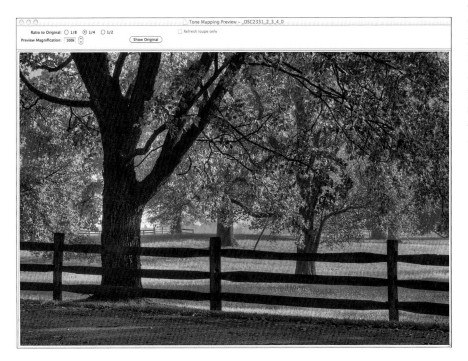

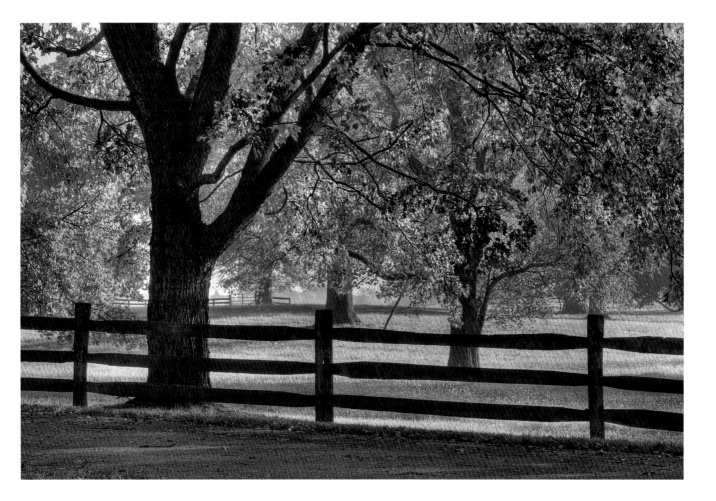

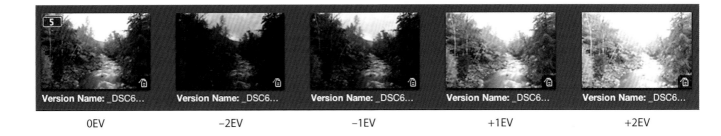

| OEV | −2EV | −1EV | +1EV | +2EV |

Mountain Stream

Crawford Notch, NH

Settings

Color Saturation: Default is 46. Set to 81 (to taste).
Luminosity: Default is 0. Set to 5.8 to lighten image to taste.
Microcontrast: Default is 0. Set to 5.6 to increase detail.
Smoothing: Set to Mid (to taste).
White point and Black point: Set to .010 to establish pure white and pure black (minimal contrast).
All other settings kept at default.

This is a classic example of why one would opt to shoot a multiple-image HDR series. The sky, even though darkly overcast, is still much brighter than the stream and treeline. This is readily apparent in the five-image strip at the top of the page. Using a split graduated ND filter won't work here given the irregular tree line, and taking one image for the sky and one image for the foreground will be quite tricky when trying to paint in the cloudy sky. But an HDR series can capture both parts of the scene.

After processing in Photomatix, the image is a bit low in contrast and oversaturated. The oversaturation was intentional, since I knew that the image would be taken into LucisPro, which tends to slightly desaturate with my presets. Photomatix and LucisPro were the only two software packages employed to render the final image.

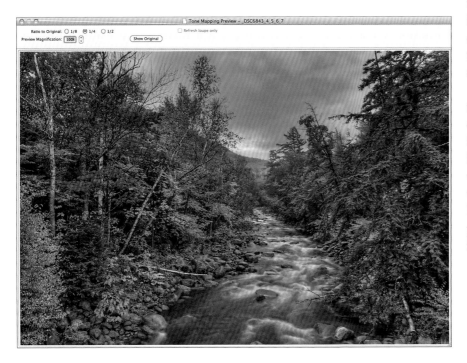

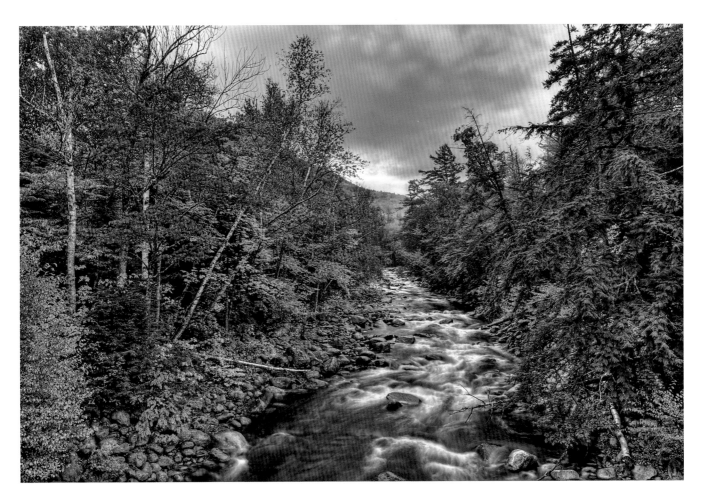

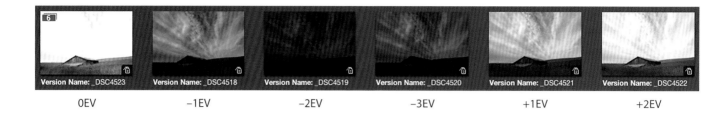

| OEV | −1EV | −2EV | −3EV | +1EV | +2EV |

Version Name: _DSC4523 Version Name: _DSC4518 Version Name: _DSC4519 Version Name: _DSC4520 Version Name: _DSC4521 Version Name: _DSC4522

Old Barn

Palouse region, WA

Settings

Color Saturation: Default is 46. Set to 89 (to taste).
Smoothing: Set to Mid (to taste).
White point and Black point: Set to .072 to increase contrast.
All other settings kept at default.

The adjustments in Photomatix with this image are mimimal and are more in keeping with how I prefer to process my HDR images, with most of the work being done in post-HDR processing. After seeing the color image, I knew that

this would be an excellent candidate for black-and-white interpretations. First off, the cloning tool was used to get rid of the phone lines to the left of the barn and the small pole to the left of the roof. Even with the minimal processing, the clouds have what I refer to as flash points—small blown-out areas. These were also fixed by cloning over the areas. Nik's Viveza was used to increase contrast and structure (detail), and to "warm" the barn. Then the image was taken into Nik's Silver Efex Pro. One of the secrets of black-and-white conversions is that in order to get the best black and white tones, the color process must be as good as if you were processing this as an ultimate color image. Because of that, my processing in SEP was minimal. I placed a control point on on the clouds to reduce structure to create more of a visual contrast between the very sharp barn and the softer clouds. Control points were also used to bring some detail in on the dark inside of the barn and to lighten the grass. Notice how the barn jumps off the page. This is the result of basically increasing contrast in the barn and slightly reducing structure in the clouds.

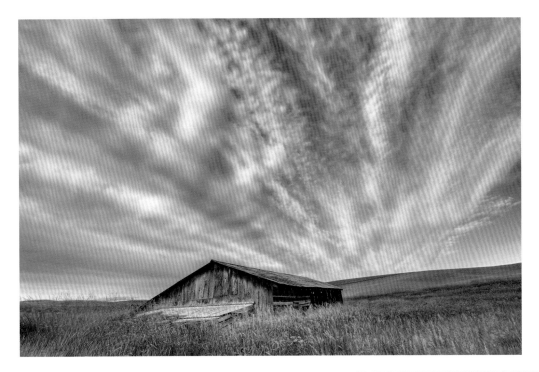

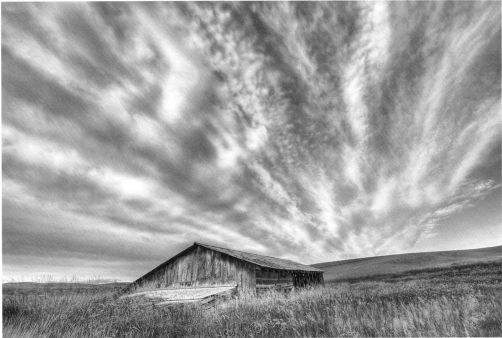

| 0EV | −2EV | −1EV | +1EV | +2EV |

Wasatch Lumber Yard

Heber, UT

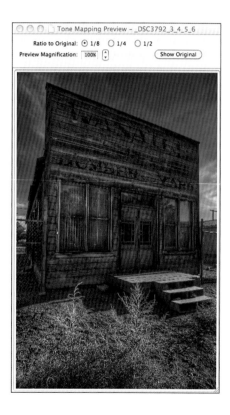

This is a standard five-image HDR series. After several unsuccessful attempts to get what I was looking for, I tried a double process, and the image I was imagining began to emerge.

Settings for the First Process

Strength: Default is 70. Maxed out to 100.

Color Saturation: Default is 46. Maxed out to 100.

Luminosity: Default is 0. Maxed out to +10.0.

Microcontrast: Default is 0. Maxed out to +10.0.

Smoothing: Set to High (to taste).

White point and Black point: Set to .010 to establish pure white and pure black (minimal contrast).

Highlights Smoothness: Default is 0. Set to 21 to tone down grain in the sky and clouds.

All other settings kept at default.

This is a great jumping-off point. The colors are beginning to pop and sky is on the right track. I made a few tweaks for the second process:

Settings for Second Process

Strength: Changed from 100 to 80 to tone down patching and grain in the sky.

Saturation: Changed from 100 to 49 to tone down gross oversaturation.

Smoothing: Changed to Mid (to taste).

White Point: Increased to .225 for extreme cloud detail.

Black Point: Increased to 2.091 to increase shadows.

Micro-smoothing: Decreased from default 9.0 to 3.6 to add grain.

Afterwards, Nik's Viveza was used to lighten the left corner of the frame, darken the dirt, and increase contrast in the foreground green bush to create depth. Finally, the storefront was lightened.

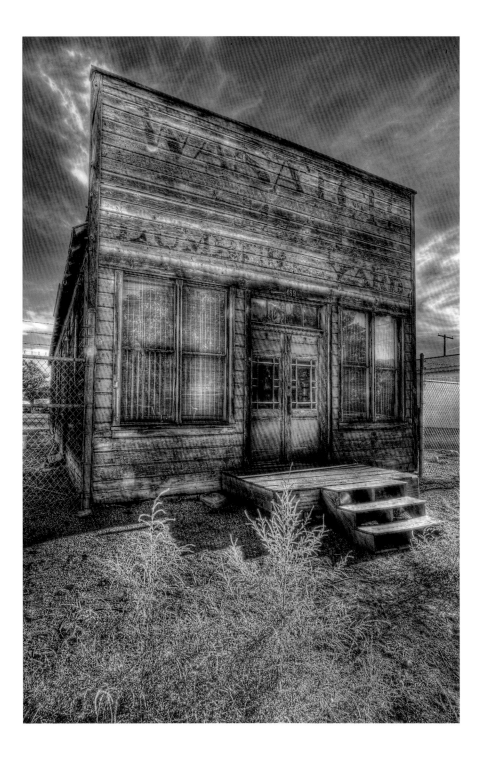

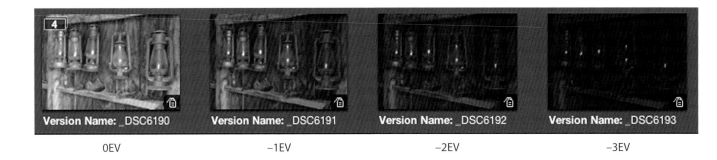

Version Name: _DSC6190	Version Name: _DSC6191	Version Name: _DSC6192	Version Name: _DSC6193
0EV	−1EV	−2EV	−3EV

Old Lanterns

Bodie State Park, CA

Settings

Strength: Default is 70. Set to 100 for greatest depth and to add contrast.
Color Saturation: Default is 46. Set to 69 (to taste).
Luminosity: Default is 0. Set to +10 to lighten image to taste.
Microcontrast: Default is 0. Set to 6 to increase detail.
Smoothing: Set to High (to taste).
White Point: Default is .250. Set to .202 to slightly darken the highlights.
Black Point: Default is 0. Set to .012 to increase contrast.
Saturation Highlights: Default is 0. Set to +3.8 with postprocess in mind.
Saturation Shadows: Default is 0. Set to −1.2 (to taste).
All other settings kept at default.

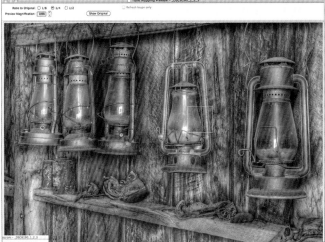

This image came very close to being completely finished in Photomatix, but it was still a bit flat. However, only minimal work was done in LucisPro to add depth, increase detail, and slightly desaturate it for a more natural look.

Notice the image strip at the top of the page. Because of the bright highlight reflections in the lamps, three underexposures were needed to bring in the highlight detail in the bright reflections. If that were not the case, the 0EV exposure would have been perfectly exposed and easily workable. During the tone mapping, I purposefully oversaturated the image, knowing that my next move was to go into LucisPro, which, with my presets, will slightly desaturate the image. If you look closely at the two images, the Lucis version has a much greater feeling of depth, almost looking three-dimensional.

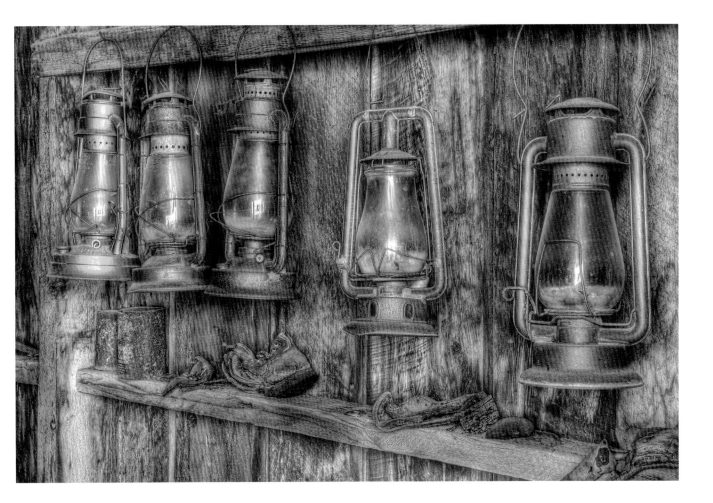

| 0EV | −2EV | −1EV | +1EV | +2EV |

End of Season

Coupeville Wharf, WA

Settings

Color Saturation: Default is 46. Set to 70 (to taste).
Luminosity: Default is 0. Set to +3.9 to lighten image to taste.
Microcontrast: Default is 0. Set to +1.9 to increase detail.
Smoothing: Set to Mid (to taste).
White point and Black point: Set to .010 to establish pure white and pure black (minimal contrast).
All other settings kept at default.

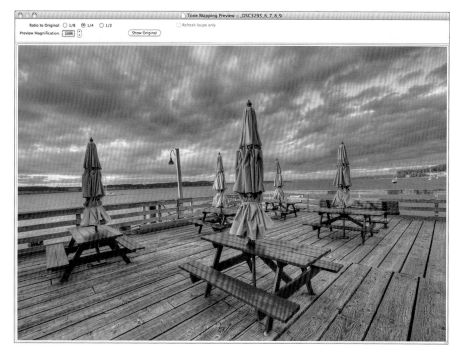

Seeing that I would need to go into Viveza for several targeted adjustments, I kept the processing in Photomatix minimal on this image. Not shown in the settings at left that the Strength was set to the default, 70. Because of the clouds, setting the strength much higher would begin to create uneven dark patching in the clouds. After applying LucisPro to intensify the image by adding contrast and detail enhancement, I used Nik's Viveza to tone down the reds, darken the boards, and warm the railing and the tops of the sunlit unbrellas. Compositionally, it was critical to have all of the umbrellas separated, creating a balanced, equidistant relationship between the large foreground umbrella and the two immediate background umbrellas. The lamp in the background was not lit and seemed a bit of a dull spot. It doesn't take much to bring an area to life, and the small light created using Viveza has visual interest and helps to pull the eye into the picture space. A wide-angle lens was used and bent slightly downwards to create the slight distortion in the frontmost table. Given that this scene has a doomsday, nuclear missle scenario feel, the distortion adds to the urgency.

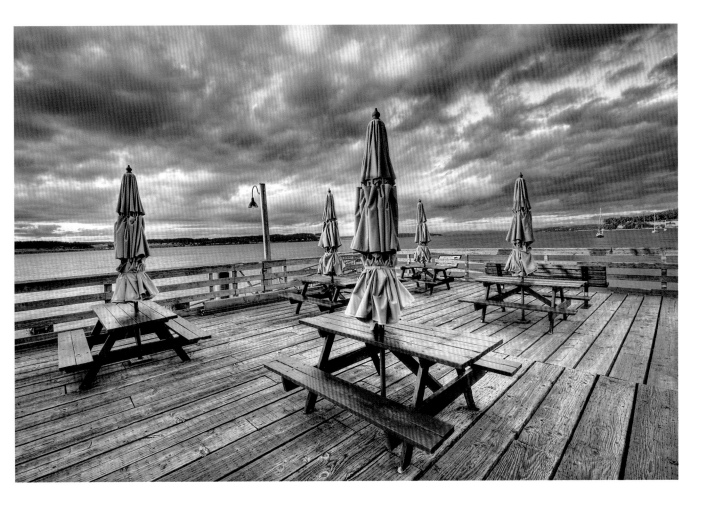

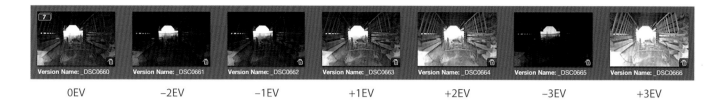

| 0EV | −2EV | −1EV | +1EV | +2EV | −3EV | +3EV |

Carriage

Cades Cove, Great Smoky Mountains, TN

Settings

Color Saturation: Default is 46. Set to 90 (to taste).

Luminosity: Default is 0. Set to +10.0 to lighten image to taste.

Microcontrast: Default is 0. Set to +4.2 to increase detail.

Smoothing: Set to High (to taste).

Black point: Default is 0. Set to 4.86 to increase contrast and to slightly darken the image.

Gamma: Default is 1.0. Set to .84 to slightly darken the image.

Saturation Highlights: Default is 0. Set to −3.6 as the sky was too saturated.

Highlights Smoothness: Default is 0. Set to 41 to smooth the clouds.

All other settings kept at default.

Lens flare is no stranger in HDR-land! This is especially true when there are very overexposed shots in a series. In order to get all the shadows in this scene, I had to go up to +3. Never a problem going the other way, to −3EV. The flare is apparent around the opening in the Final Process image, below. The enhance detail tab in the LucisPro image added contrast, which tightened up the flare around the edges, but it's still there. The LucisPro image is actually good as is for a superrealistic look. But I chose to blend the Final Process and LucisPro image together, adjusting the opacity to get the image that appears on the opposite page. On the main image, I had to paint around the edges of the opening to paint out the flare, which manifests itself in the bright, soft edges around the opening.

Note: Keeping the Strength setting to the lower default helped to keep the sky even-toned and to avoid haloing. Also, a low light smoothing is a well-known culprit in creating harsh halos, which should be avoided.

Final Process

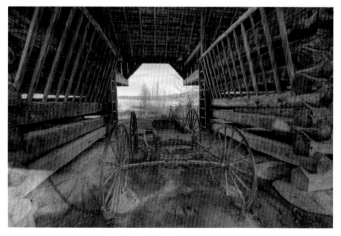

LucisPro with my presets

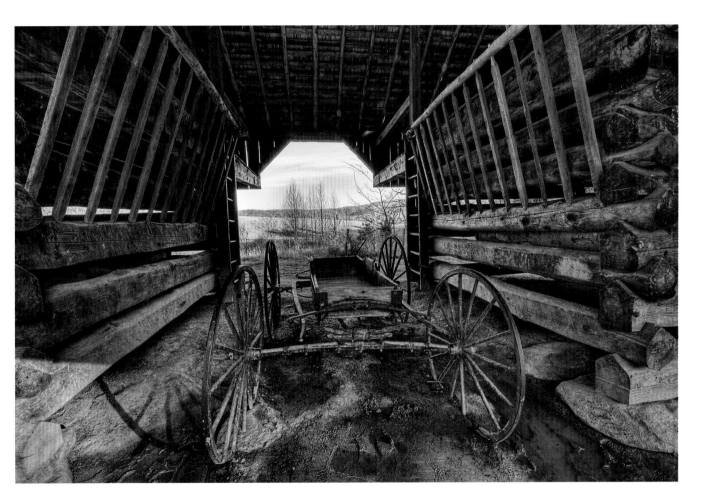

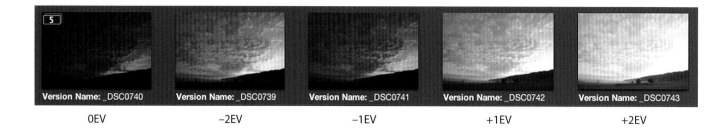

| 0EV | −2EV | −1EV | +1EV | +2EV |

Dawn Clouds

Worthington Valley, MD

Settings

Luminosity: Default is 0. Set to +6.0 to brighten the image.
Microcontrast: Default is 0. Set to +3.7 to increase texture
Smoothing: Set to High (to taste).
All other settings kept at default.

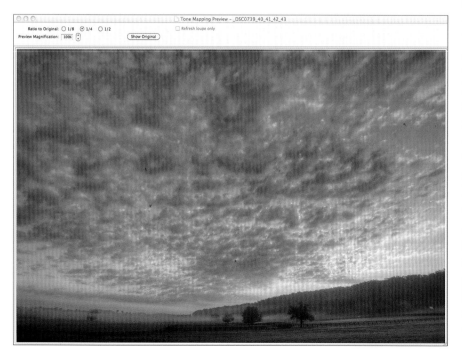

This scene looks like one shot would get it, but looks can be deceiving, as you can see from the image strip. The light on this scene was very delicate and I knew that Photomatix would have a difficult time doing what I wanted. So, as you can see from the settings, I did very little. Think of it as priming the image for optimization. Nik's Viveza 2 has the ability to do selective and global adjustments. On the top image on the facing page, I increased brightness (minimal), increased contrast (minimal), increased saturation (minimal), and decreased structure. Decreasing structure smoothed out some of the detail in the clouds, creating a softer feel. However, the finishing touches were on the final image, where a low opacity Alien Skin Oil Paint filter was applied (this texture is shown in the lower close-up on the next page); the green grass foreground was dramatically brightened as well, creating a lighter feel. The final image better expressed what I was feeling that morning.

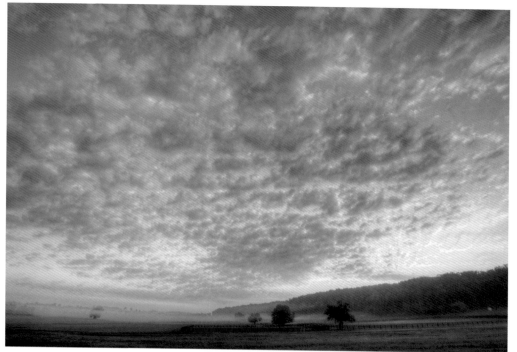
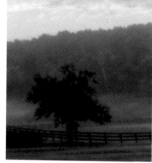
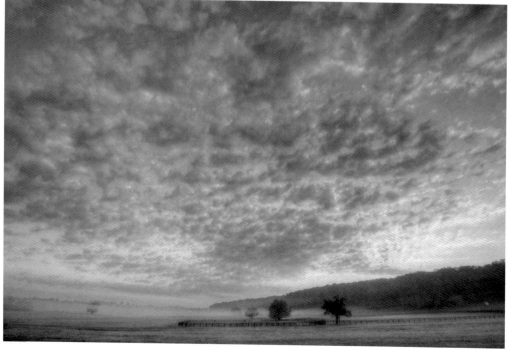

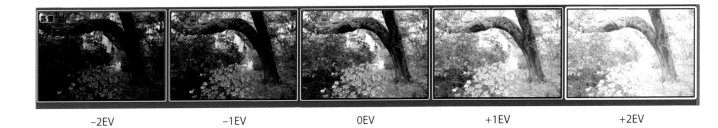

| −2EV | −1EV | 0EV | +1EV | +2EV |

Secret Pathway

Magnolia Gardens, Charleston, SC

Settings

Color Saturation: Default is 46. Set to 70 to bring in the reds and pinks.

Luminosity: Default is 0. Set to +6.2 to brighten the image.

Microcontrast: Default is 0. Set to +6.1 to increase texture

Smoothing: Set to High (to taste).

White point: Default is .250; Black point: Default is 0. Both set to .125 to increase contrast.

Micro-smoothing: Default is 9.0. Set to 2.0 to enhance detail and texture.

All other settings kept at default.

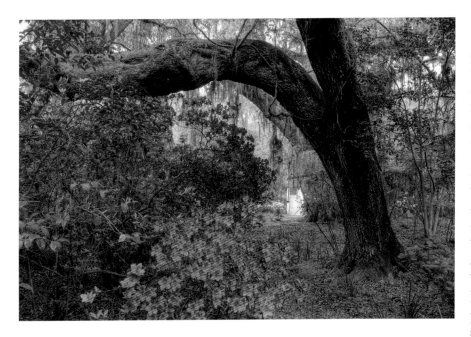

Shooting from inside this recessed area to the bridge area and foliage outside this area necessitated the use of an HDR series. This is apparent from looking at the HDR image series. Even though it was a bright overcast day with no harsh shadows, the exposure where the foreground shadow detail was rendered well (0EV) had many hot spots and the small footbridge was completely blown out. And the inverse was true—when the bridge was properly exposed, the large foreground shadow area was almost completely black. Since noise resides in the shadow areas, and since HDR is a noisy process, bringing up the exposure would certainly result in unacceptable grain.

After this image was processed to taste, it still didn't have the right feel. The detail of the leaves and twigs under the overarching branch and to the right of the trunk was distracting. There are many ways to take the edge off of an image. In this case I chose Topaz Simplify. Minimizing the BuzSim effect by lowering the Simplify size and Details size and then slightly desaturating the image achieved the smoother effect I wanted.

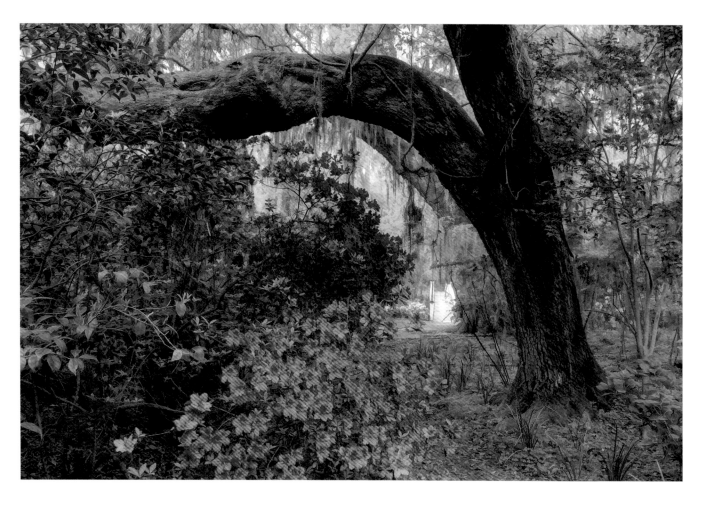

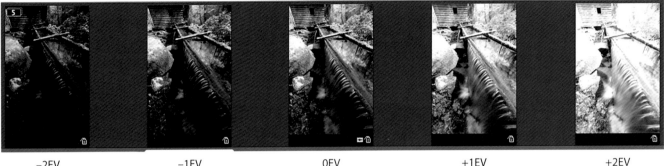

| −2EV | −1EV | 0EV | +1EV | +2EV |

Roaring Fork Mill

Great Smoky Mountains, TN

Settings

Strength: Default is 70. Set to 80 to increase contrast and overall HDR effect.

Color Saturation: Default is 46. Set to 70 (to taste).

Luminosity: Default is 0. Set to +6.2 to brighten the image.

Microcontrast: Default is 0. Set to +7.0 to increase texture.

Smoothing: Set to Mid to increase detail in the shaded areas to the left of the trough.

White point and Black point: Set to .010 to establish pure white and pure black (minimal contrast).

All other settings kept at default.

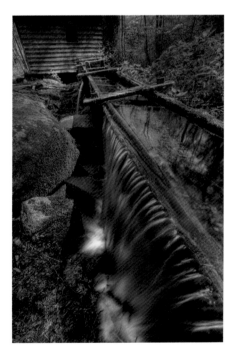

This image had a lot of post-HDR work done to it. First, note how the initial Photomatix output requires additional contrast in post-HDR processing. In this case, Topaz Adjust was chosen, because the interplay of the Exposure and Regions sliders can punch up detail under the water. Then I used a couple of Nik filters. The contrast color range filter from Color Efex Pro was painted in at a high opacity on everything but the water. High contrast at a high opacity made the water too contrasty, but it worked when painted in at 50% opacity.

Next, the following targeted adjustments were made in Viveza 2: The mill was lightened and warmed; parts of the water in trough were lightened; the greens in the upper right corner were lightened; and the black patches of water at the lower bottom of the image at the left were cloned over at a low opacity to achieve a good and seamless blend, as seen in the final image on the right.

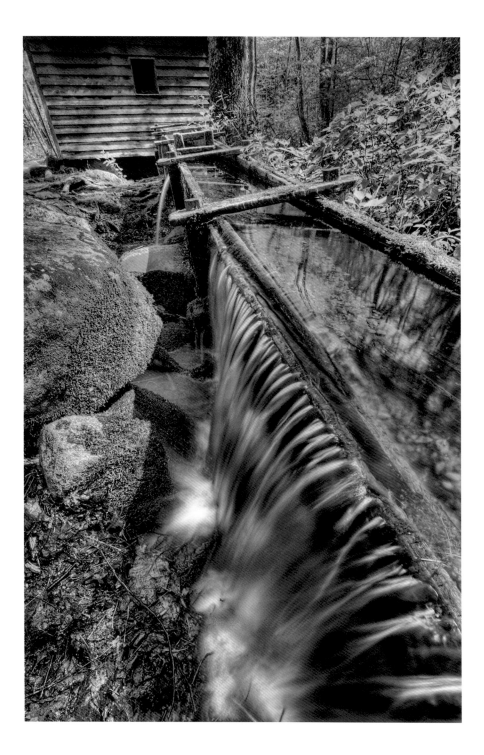

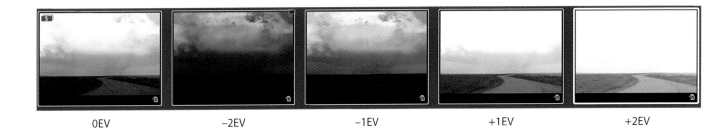

| 0EV | −2EV | −1EV | +1EV | +2EV |

Storm Cloud

Badlands National Park, SD

Settings

Strength: Default is 70. Set to 100 to increase contrast and overall HDR effect in the clouds.

Color Saturation: Default is 46. Set to 100 to dramatically increase saturation in the foreground.

Luminosity: Default is 0. Set to +10 to dramatically brighten the image.

Microcontrast: Default is 0. Set to +6.2 to increase texture.

Smoothing: Set to Max (to taste—in other words, it looked the best of the three higher options).

White point and Black point: Set to .010 to establish pure white and pure black (minimal contrast).

Micro-smoothing: Default is 9.0. Set to 11.2 to lighten and smooth clouds.

All other settings kept at default.

Although clouds are somewhat integral to compelling HDR nature photography, they can be a bit tricky. Too high a strength or microcontrast setting or too low a light smoothing setting can create very dark to black areas in the extreme. However, a small bit of the HDR effect can create depth and a look of three-dimensionality in clouds. In this case, because of the low-contrast nature of this scene, the strength, color saturation, luminosity, and light smoothing were set to the maximum settings. Nik's Color Efex Pro's graduated neutral density filter was used to slightly darken the clouds and sky and to lighten the lower portion of the image. Finally, Nik's Viveza was used to target the road to brighten it a bit more and to add a bit of warmth by increasing white balance.

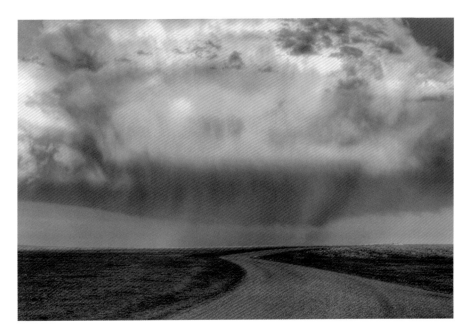

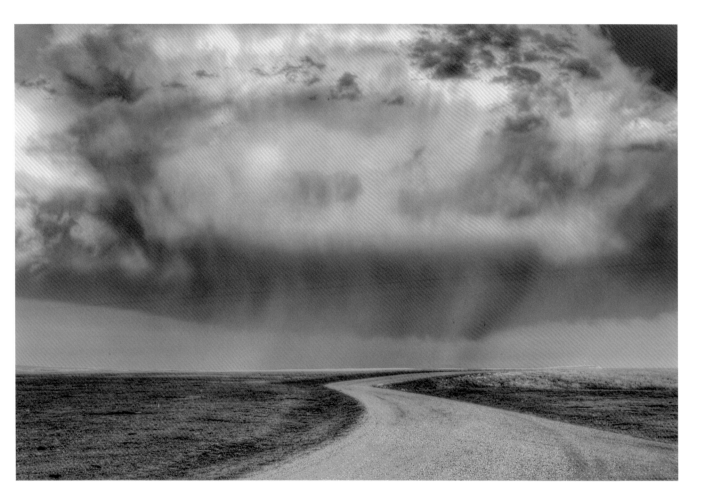

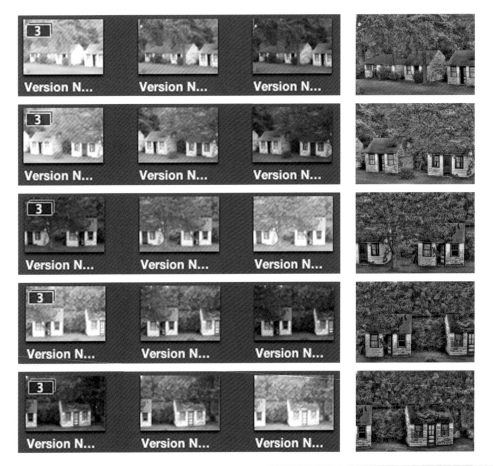

Version N... Version N... Version N...

Version N... Version N... Version N...

Version N... Version N... Version N...

Version N... Version N... Version N...

Version N... Version N... Version N...

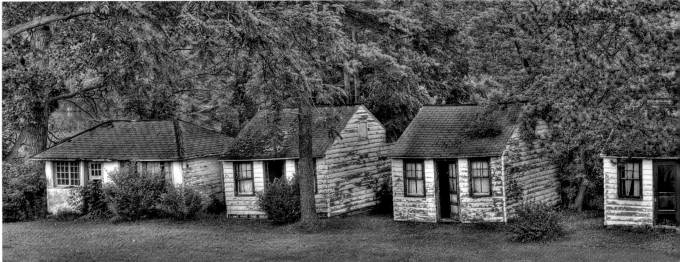

Workers' Quarters

Geneva, NY

All image sequences were shot at +IEV, 0EV, and −IEV.

 The rightmost image of each set here is the tone mapped version.

 A basic feature of Photomatix is that when you tone map a new image, the settings automatically come up as the previous image settings. This can be a good thing in many situations, because it may save you some time, but it is particularly effective when tone mapping a panoramic HDR series like this. Once I have the settings I like on the first series, all the remaining images series open with the same tone mapping settings. There is no need to change any adjustments; just press "Process" on each successive image sequence!

Settings (All Images)

Strength: Default is 70. Set to 100 for maximum HDR effect.

Color Saturation: Default is 46. Set to 69.

Luminosity: Default is 0. Set to +4.1 to brighten the image.

Microcontrast: Default is 0. Set to +4 to increase texture.

White point and Black point: Set to .225 to increase contrast only.

Smoothing: Set to Mid (to taste).

All other settings kept at default.

The postprocessing was done using Nik's Viveza 2, increasing brightness, contrast, and structure to taste.

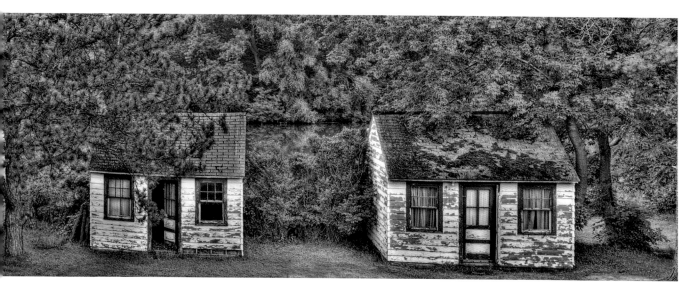

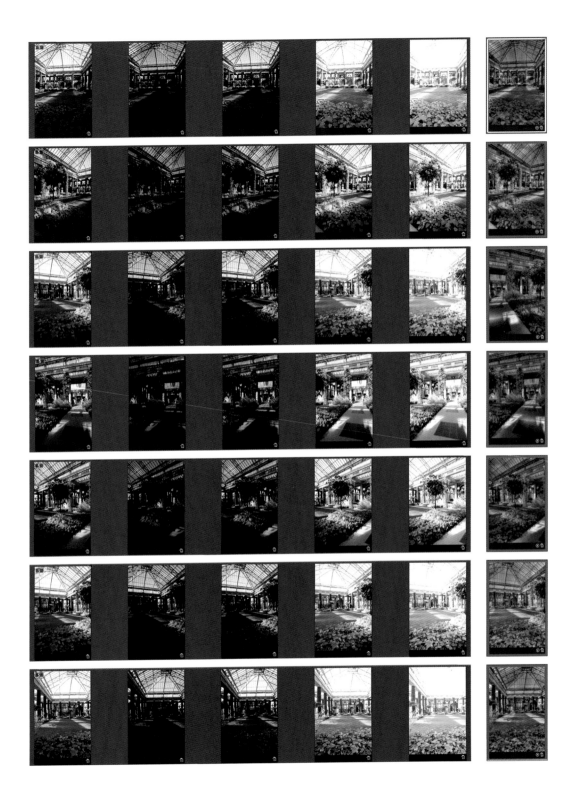

Conservatory

Kennet Square, PA

Settings (All Images)

Color Saturation: Default is 46. Set to 79 to increase global saturation.
Luminosity: Default is 0. Set to +8.1 to brighten the image.
White point and Black point: Set to .075 to slightly increase global contrast.
Smoothing: Set to High (to taste).
All other settings kept at default.

Aside from a few specular highlights in this conservatory, the light was fairly even, with a few areas of high contrast.

Seven five-image HDR series were able to capture all detail and highlights. As with most HDR-processed images in Photomatix, the image is a bit flat, despite the increase in the White Point and Black Point settings during the tone mapping process. However, further increasing contrast slightly in curves was all that was needed to create the extra little "pop" in the final image on the next pages.

The workflow was to process each image series of five images (standard HDR sequences of 0ev, −2ev, −1ev, +1ev, +2ev) to produce the final image at the extreme right side of each row of images. Since the previous image setting comes up automatically in Photomatix, as in the previous example, processing large images sets is greatly facilitated. After all seven rows of images were tone mapped, the resulting images from each row were stitched together in AutoPano Pro software. Photoshop's Photomerge works very well also.

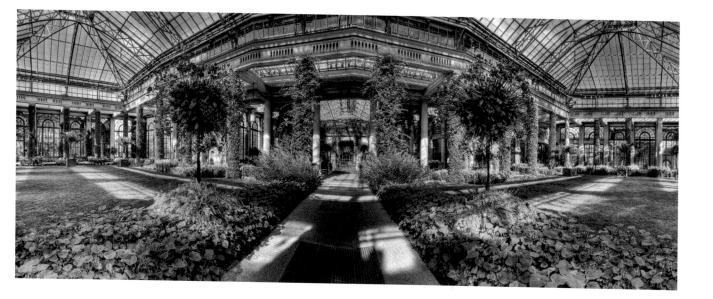

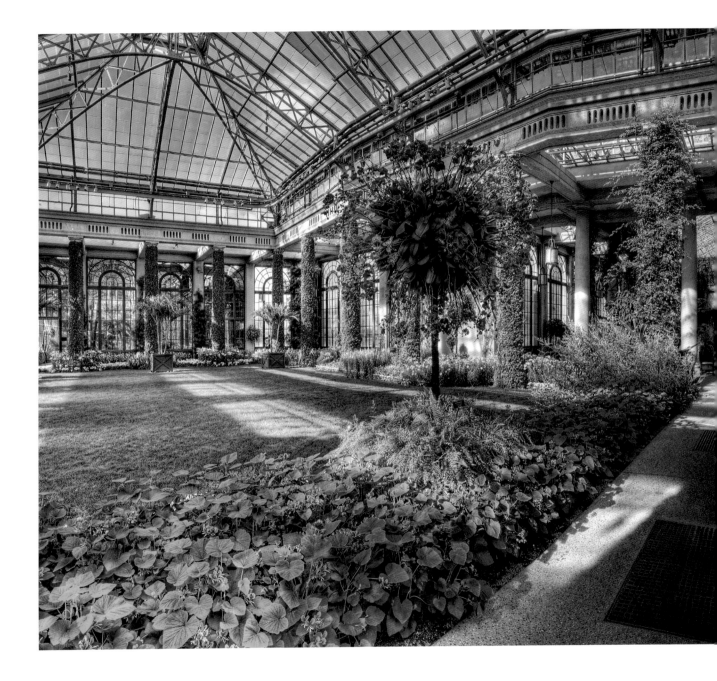

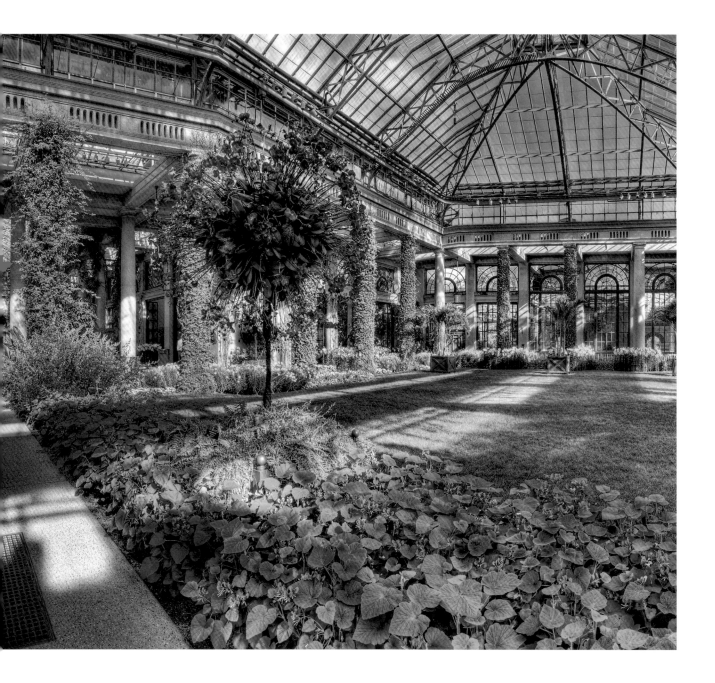

| 0EV | −2EV | −1EV | +1EV | +2EV |

Sunstar

Bryce National Park, UT

Settings

This image was unusual in that aside from a minor white point adjustment, it was processed at the default settings.

White point and Black point: Set to .010 to establish pure white and pure black (minimal contrast).

All other settings kept at default.

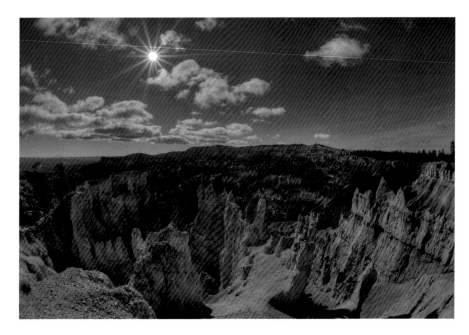

After all exposures were combined, it was apparent during tone mapping that many of the controls would adversely affect the sky, clouds, or reds. I chose to perform various contrast adjustments using Nik Software plugins. After cloning out dust specks, I chose Nik's Color Efex Pro color contrast range filter, keeping the setting at the default, but choosing the brush option. This enabled me to paint the contrast adjustment into the bright foreground spires at 66% opacity, into the background spires at 50%, and into the sky at 20%. This was done to create a feeling of depth while leaving the sky largely unaffected. Next, I used Viveza to further darken the background hills, creating more separation and adding to the sense of depth. It's important to point out the sunstar from the unobstructed and hot sun. This is a function of the 16mm fish eye lens shot at f/22. Also, the classic fish-eye bowed horizon look was avoided here by holding the lens perfectly level. This results in a dead center horizon, which seems to work ok on this image.

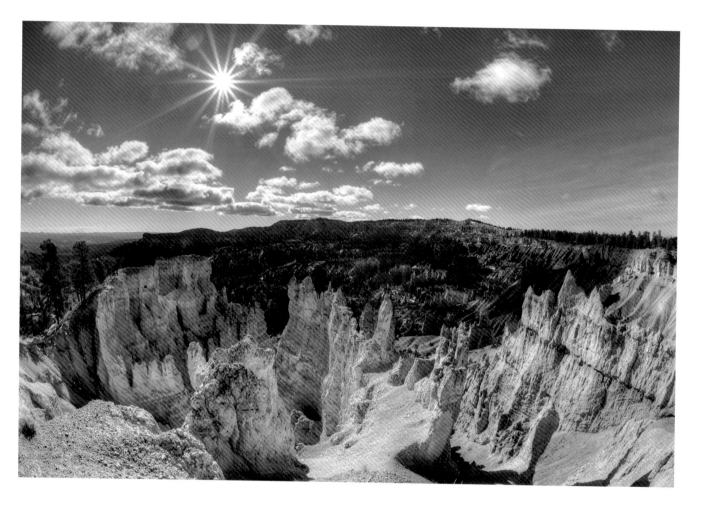

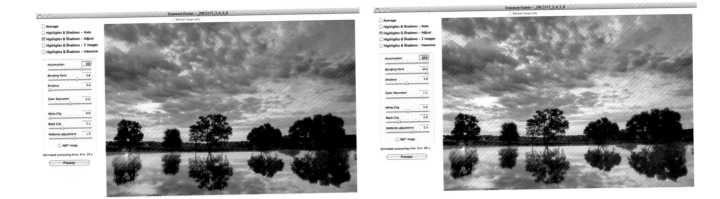

Barb Williams Pond

Worthington Valley, MD

Another feature in Photomatix is Exposure Fusion. It's possible to get the same results Exposure Fusion provides by tone mapping the HDR output in Details Enhancer. However, opinions vary and many photographers prefer to use this option to achieve a more natural look.

In the top two images, the first image is the default settings in Exposure Fusion. The one on the right is the adjusted image. There isn't the range of controls available in Exposure Fusion that there is in the Details Enhancer, but if the processing is minimal, there may not be a need for the extra controls.

On the opposite page, the top image is a larger version of the adjusted Exposure Fusion image and the bottom image is tone mapped, taking advantage of the strength and microcontrast controls to create greater drama and a superrealistic look.

One advantage to the Exposure Fusion method is that it is a much less noisy, cleaner process.

After tone mapping the bottom image on the right, I then applied Lucis-Pro, at a low opacity, to increase contrast. After the Exposure Fusion image was processed, no other work was needed.

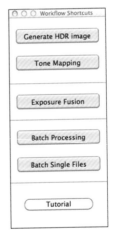

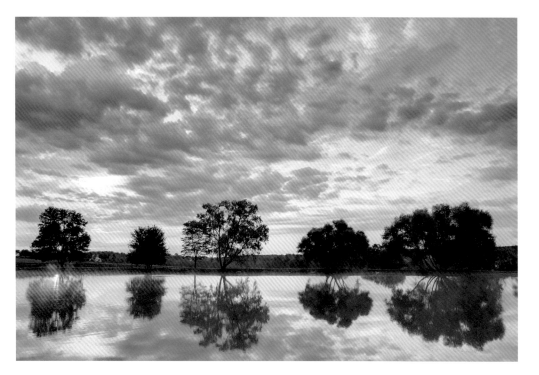

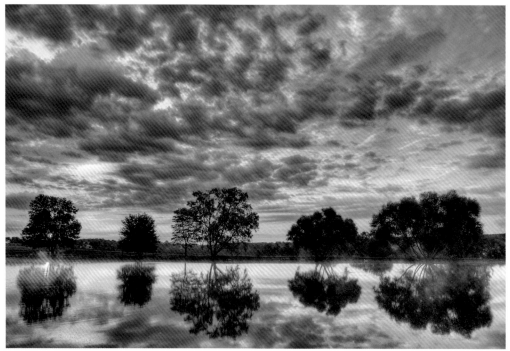

HDR Efex Pro

HDR Efex Pro, a program by NikSoftware (http://niksoftware.com) is relatively new and has a very different look from Photomatix.

Let's have a look at the user interface:

The first thing to notice is that after selecting and importing the images, the next stop is the HDR Efex Pro window workspace. You are presented with a series of presets in the left-hand column and specific adjustment controls on the right hand column. It is a very clean and simple design. Right above the presets are categories. You can click on the top button to show all or on individual categories, such as Realistic, Artistic, Landscape, and so on. If I find myself selecting a specific preset frequently, I'll click on the gray star under the preset. The star turns red and that preset appears in the last category: Favorites.

Let's have a look at the controls on the right side of the window.

Tone Compression: A low setting cancels out the HDR effect, resulting in a more natural-looking image. A high setting increases the HDR effect by compressing the highlights and shadows.

Global adjustments: Exposure, contrast, and saturation are set to taste.

Structure: This has the effect of bringing in more detail, but can look a bit over-sharp if too high a setting is used. In general, keep the use of the structure control to a minimum; a little structure goes a long way.

Blacks and whites: This is actually black and white points. Increasing black point dramatically will result in unacceptably dark areas and increasing white point dramatically will result in blown-out areas. As with all settings, start conservatively and gradually take the image where you want to go.

Warmth: This is the white balance. Moving to the right will add warmth. Moving the slider to the left will cool down the image.

HDR method: A dropdown menu has myriad options from which to choose the overall look of the effect.

Method Strength: This slider can be moved to increase or decrease the HDR effect of the chosen HDR method.

Selective Adjustments: You can add a control point to any part of the image to selectively control any of the above settings, but in a smaller controlled area.

Finishing Adjustments: Here you can add a vignette and adjust curves, manually or by using levels and curves presets.

Loupe and Histogram, at the bottom of the window, are useful tools. The loupe shows you a magnified view of the area where the mouse is placed. The histogram displays the tonal distribution of your image. Basically, just avoid creeping up the right side of the histogram.

At the very top left of the screen are icons for various editing views.

The preview button can be pressed to toggle between the original and adjusted images. This can more easily be accomplished by merely pressing the P key.

The Alignment and Ghost reduction tool works remarkably well to reduce ghosting when movement occurs during the image series.

Further along the upper part of the box is the zoom box, which can display the image at various magnifications.

Clicking on the light bulb changes the background color to white, gray, or black.

Clicking on the arrow closes the right column for a larger image view.

Let's process an image using HDR Efex Pro.

We begin by importing the image series into HDR Efex Pro.

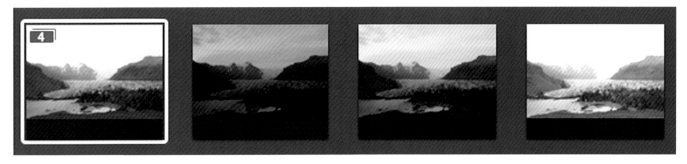

The image on the previous page is the default setting—a bit flat, but a good jumping-off point. As you can see in the subsequent example, I selected the Favorites category, and then in the presets, the Dramatic Landscape setting. This is a good point to begin selective adjustments.

Global Adjustments

Working from the Dramatic Landscape preset, I added the following fine-tuning adjustments:

- Slightly increased exposure by .3ev.
- Increased saturation by 22%.
- Slightly increased Whites (white point) to slightly brighten the image.
- Increased the HDR effect strength to 22% to taste.

Selective Adjustments

Contols points were placed in the sky to bring out the color. Control points were placed to brighten up the darkest parts of the glacier

The image was processed and saved, and reopened in Photoshop.

I selectively painted in "Contrast Color Range" and "Contrast Only," using Nik's Color Efex Pro for the final rendering (shown on the next page).

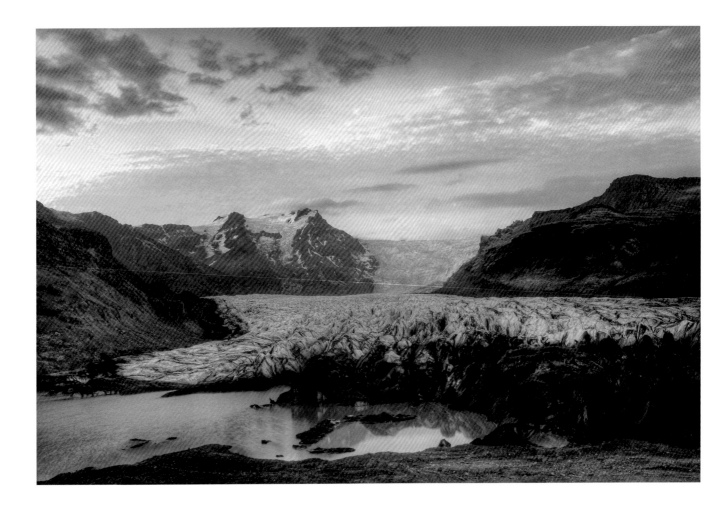

Here are some very cool HDR Efex Pro features:

- Consistency—the plugin acts the same in Aperture, Lightroom, and Photoshop.

- There are a number of different presets to select or to use as a starting point.

- Nik's patented U-Point can be used to target and adjust specific parts of the image during the HDR process. It contols Exposure, Contrast, Saturation, Structure, Blacks, Whites, Warmth, and HDR Method Strength, so the HDR strength in a targeted area can be decreased.

- HDR Efex Pro utilizes four algorithms, resulting in many different looks, not just one signature look.

- There is an excellent vignetting tool.

- There are Levels and Curves presets as well as a live curve for manual adjustments.

Let's have a look at some images processed using HDR Efex Pro.

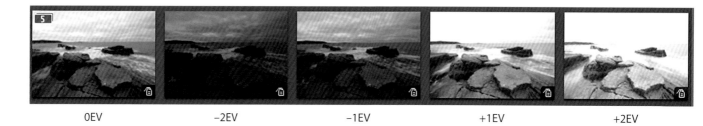

| 0EV | −2EV | −1EV | +1EV | +2EV |

Thunder Hole

Acadia National Park, ME

After you process the image set in HDR Efex Pro, the default version appears. Notice that the default version's settings are all in the middle of the scales. When a preset is selected, the controls change to reflect the preset.

Although there are areas that need adjustmentments, this image is an excellent jumping-off point. Nature images rarely, if ever, work if there is too much tone mapping. I normally cycle through the presets, which is generally a good way to start, then fine-tune further using the controls in the panel on the right. In this case, the image is close enough to what I want that I will go directly to the right panel to fine tune.

Note: When finished with the presets, you can close that panel by clicking the icon at the upper left corner, which results in a larger viewing area, leaving only the image and the controls on the right side.

Tone compression is my first adjustment. Increasing this setting brings the tones closer together, slightly darkening the clouds and slightly brightening up the rocks. The only other setting used in these initial controls was an increase in warmth to lighten the rocks. I chose to keep the default setting (Natural). Increasing Method Strength created more drama in the clouds and further lightened up the rocks. Three targeted control points were used to affect the rocks only across the bottom of the frame, increasing structure only, as I did not want to affect the clouds at all. I finished up with a subtle vignette to pull the viewer into the scene.

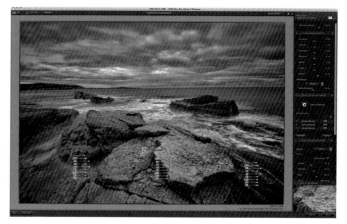

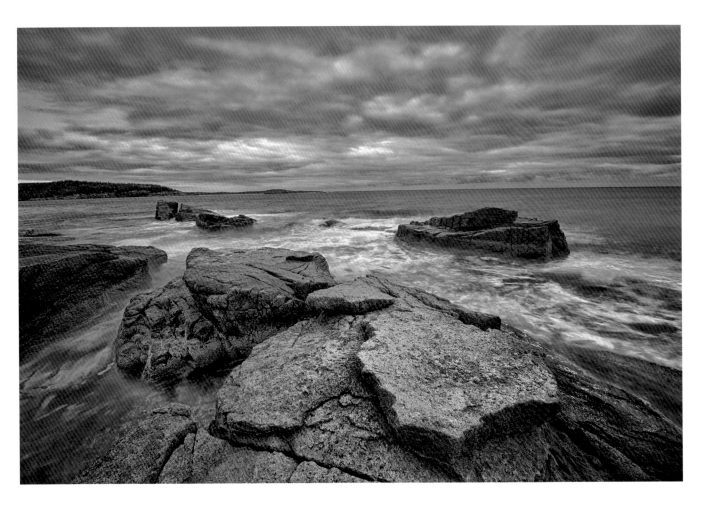

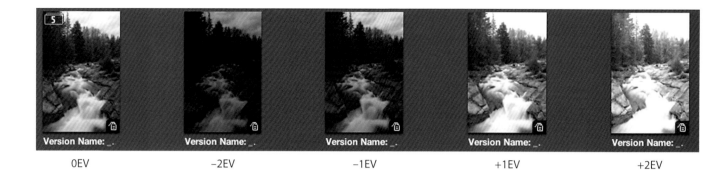

| OEV | −2EV | −1EV | +1EV | +2EV |

Base Station Road

White Mountains, NH

This image was made very late in the day, requiring a thirty-second exposure. I used the Singh Ray Vari-N-Trio to polarize and to punch up the overall color and to dramatically increase the five exposures to ensure smooth water.

Note: For smooth water for an HDR image, the base exposure should be two to eight seconds long. That way, the shortest exposure, −2ev, will still be long enough for silky water.

The original image is a bit dark, but almost captures the dark mood of this dark overcast fall afternoon. After trying a few presets, I chose to go with the default setting and moved immediately to the adjustments, closing the left panel for a cleaner viewing window.

Tone compression was increased to increase detail in the clouds and to brighten the foreground. Then the Method Strength was increased to taste. After a small global increase in contrast, the remaining adjustments were made using control points. Notice that to avoid contol point bleed, which can be an issue on occasion, I set a series of identical control points across the treeline to increase contrast, exposure, and warmth. I then toned down the amber in the leaf groups and added warmth to the very blue rocks. This resulted in a believable, yet super-realistic look.

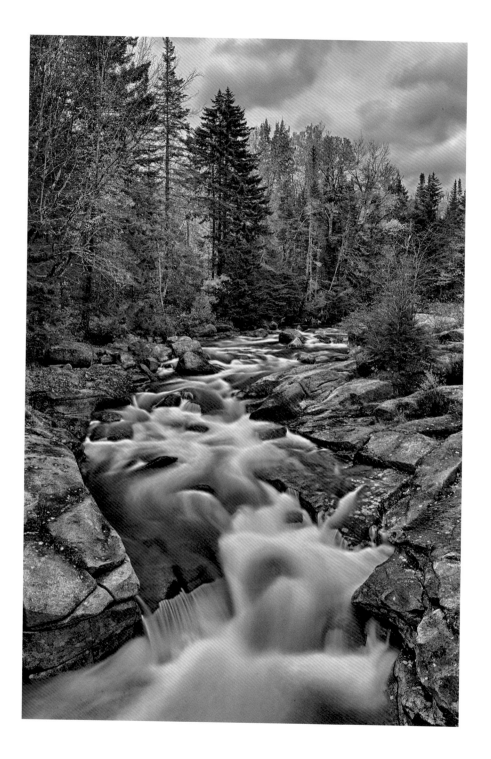

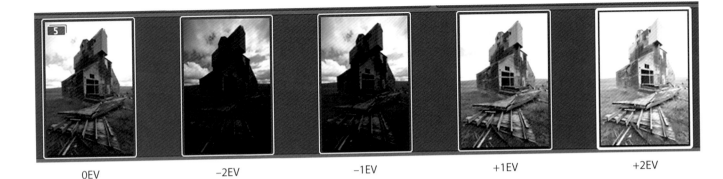

| 0EV | −2EV | −1EV | +1EV | +2EV |

Old Grain Elevator

Colfax, WA

The "Soft" preset was chosen as a starting point for this interpretation because I liked the slight vignette and the detail in the white clouds.

All that I really needed on this image was a control point on the wood. As you can see in the second example, the following adjustments were made: I increased contrast and lowered saturation to get the wood to look more natural. There was a blue cast in the original, so I increased warmth, adding amber to the mill.

Note: Control points can, on occasion, bleed, affecting areas outside of the circle. In this case, the controls on the wood increased saturation in the grass, which was acceptable. Placing a default control point on an area will protect it against bleed or return an affected area to the original. Protection means that if the control point is placed on an area first, subsequent control points will not affect the protected area.

78

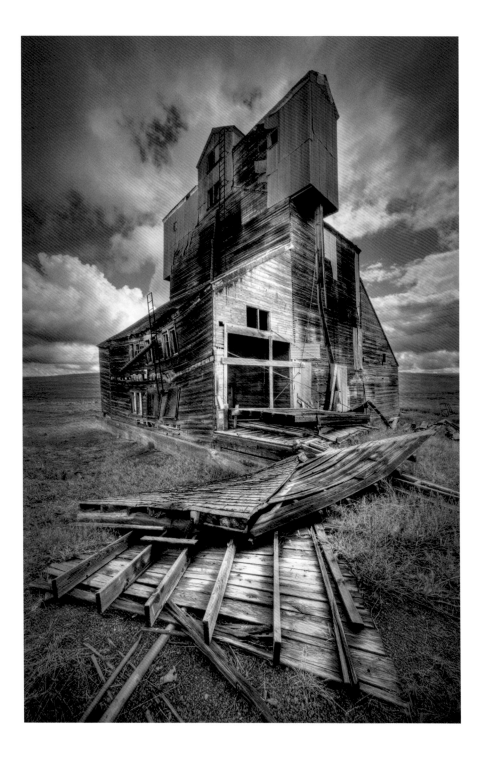

0EV −2EV −1EV +1EV

Old Boat House

Coupeville, WA

Notice that one of the images is extremely dark. This image was included to show you that it is possible to exclude images that are obviously too dark, or in some cases, too light. I processed the first, third, and fourth images in HDR Efex Pro. The default image wasn't close to the feeling I had in mind for this image, so I perused the presets and chose Granny's Attic as a jumping-off point. The less saturated, vintage look was in the ballpark of what I was looking for.

After choosing the Granny's Attic preset, I added two control points to the upper left and upper right parts of the frame to tone down the bright hot spots in the wood.

I then added a control point to the large brown bottle and a control point to the green bottle to increase contrast.

Note: Adding contrast to a foreground element will tend to separate it from the backgound, adding more depth to the image.

The image on the right was the picture I was seeing in my imagination when making this image.

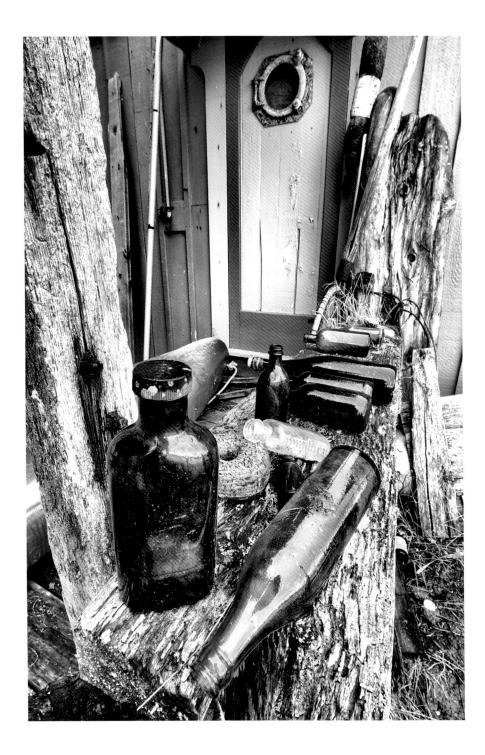

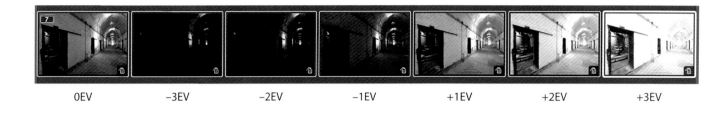

| 0EV | −3EV | −2EV | −1EV | +1EV | +2EV | +3EV |

Barber's Chair

Eastern State Penitentiary, Philadelphia, PA

This is one of the iconic subjects from Eastern State Penitentiary, a national historic site in Philadelphia. I've shot the chair many times, but with no one in this very popular cell block on this particular day, I took the opportunity to photograph the uncluttered hallway, featuring the barber's chair. The initial HDR merging came out pretty well, but the way it looked didn't really capture the oppressing feel of the place.

Increasing the Tone Compression brought in the detail at the end of the hallway. Increasing contrast and structure and underexposing a bit created the grungy, detailed, darker feel. The saturation was also decreased to taste. Increasing the HDR Method to taste was the final global adjustment.

Since the room is an integral element in this image, I placed four control points to saturate, add contrast, and brighten the room to pull the eye there first before moving to the end of the hallway.

Still not satisfied, I created a black-and-white version in Silver Efex Pro with increased contrast and structure. Silver Efex Pro renders a new layer, making it easy to paint the colorful barber's chair back into the black and white image.

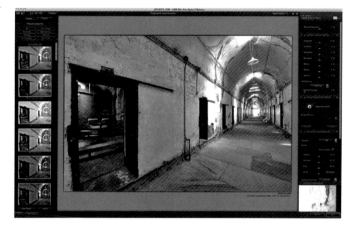

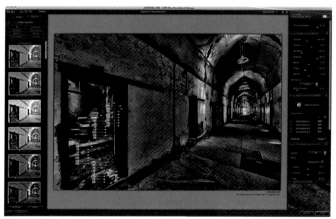

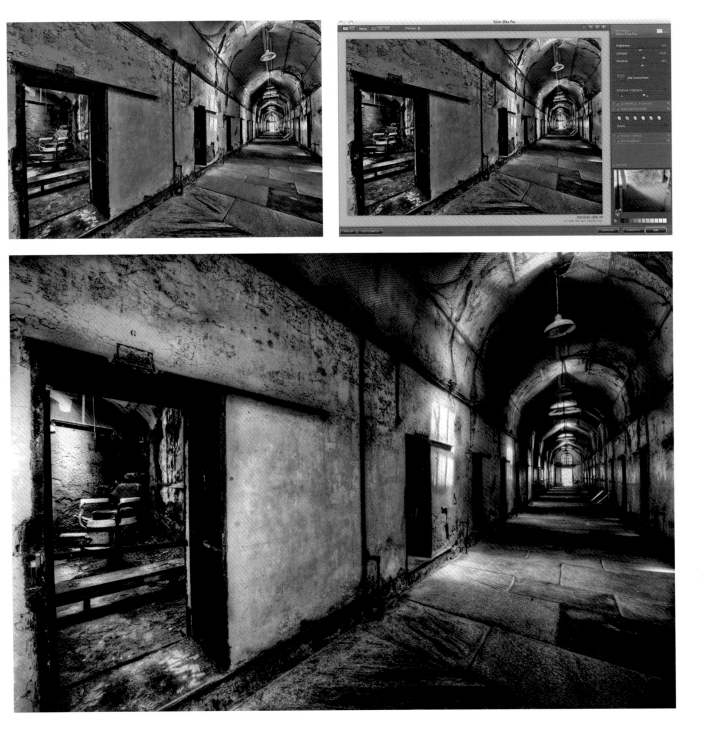

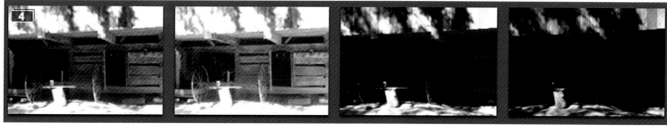

| 0EV | +1EV | −2EV | −4EV |

Old Barn

Cable Mill, Great Smoky Mountains, TN

Here's an example of a series of exposures shot in very bright sunlight into the deep shade in the old barn. Notice that the increments between exposures are not single full stops, but jump by two stops on the minus side. After shooting on meter and then +1ev to bring in all the shadows, it was apparent from seeing the histogram, and just looking at the scene, that the negative exposures would be extreme. Going immediately to −2ev was a good start, but I needed −4ev to bring in all of the highlights on this bright sunny day. The first screen capture shows the default preset.

I began with the Strong Realism preset, then increased the tone compression slider to bring the strong highlights and deep shadows closer together. Contrast was increased. Saturation and warmth were turned down for a more natural wood look. Structure was increased to add texture and white point lowered to darken the image slightly.

Notice in the upper left corner that the Custom presets are selected. I decided that these settings could possibly be used on other images, so I clicked on the "+" sign and named this preset. Now, all I have to do is click that preset to apply these settings in the future.

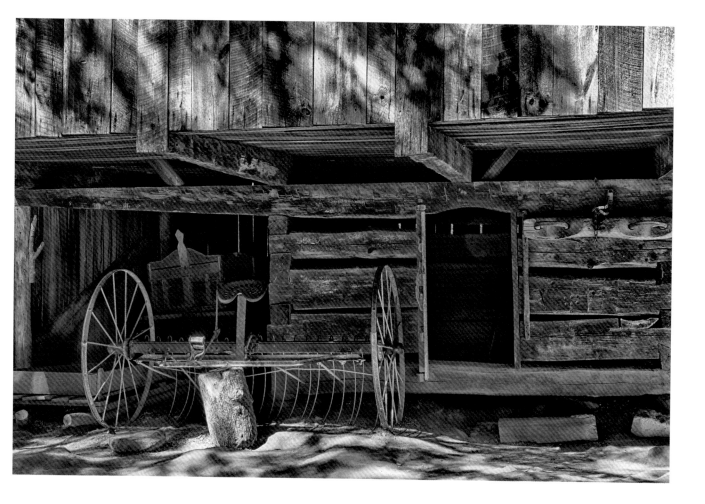

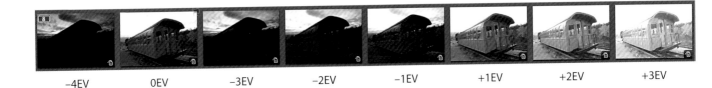

| −4EV | 0EV | −3EV | −2EV | −1EV | +1EV | +2EV | +3EV |

Passenger Car

White Mountains, NH

The first thing to notice here is that the exposure sequence appears to be non-sequential. My initial guess, based on experience and seeing the initial histogram, was to shoot a seven-image sequence. Upon checking the −3ev histogram, I decided I needed one more underexposure to get all of the cloud detail in the brightest part of the sky. So I turned off auto bracketing and shot one more image at −4ev.

After cycling through the presets, I settled on the "14 Warm Details" preset to begin with, knowing that I would need to alter the image in the settings and by adding control points.

The only changes that were made from the original preset were to dial back structure and lower Tone Compression in order to take some of the "crunch" out of the clouds and to add color back to the sky.

Three control points were added to finish off the image processing (from left to right): a control point was placed in the grass to increase contrast and saturation; a control point was placed on the blue of the railroad car to increase saturation; and a control point was placed on the door to add warmth, contrast, and structure, accentuating the warm tonality against the blue of the car for visual punch.

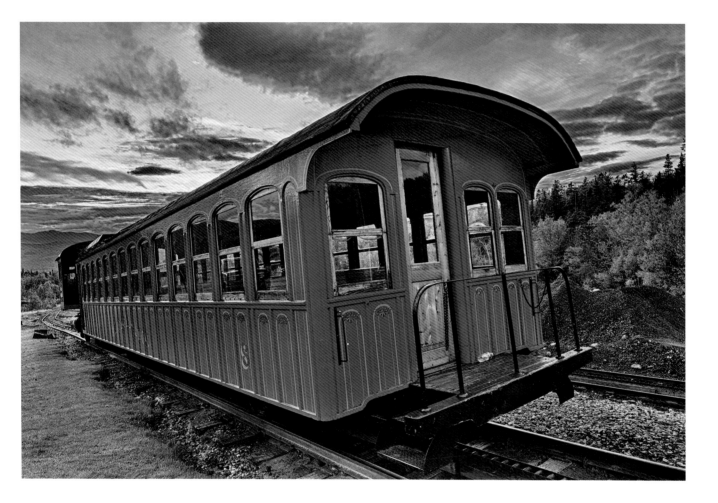

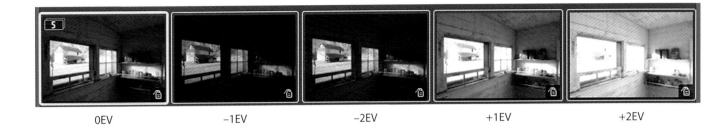

| 0EV | −1EV | −2EV | +1EV | +2EV |

Zimmerman's Farm

Delaware Water Gap, PA

This is a classic scene from one of our workshop locations and is a classic HDR situation. Shooting from inside out would, in the past, result in either a properly exposed inside and a blown-out outside, or a properly exposed outside and a very dark inside. Of course, HDR can solve this dilemma with an exposure series to cover the entire dynamic range. The standard five-image (three-image for Canon) exposure series, shot in A mode, bracketing with exposure compensation, got the entire dynamic range.

Although too warm and lacking impact, the "02 Balanced" preset had the basic raw material.

Tone compression was increased to bring the highlights and shadow areas closer together, which is always a good place to start. Exposure was brought down a bit to globally darken the scene. Contrast was increased to taste. Structure was dramatically increased to exaggerate detail. Black point was increased and white point was decreased, which had the effect of increasing contrast.

Control points were placed in the area under the collapsed roof in the framed barn to bring in some detail, to avoid having a black hole there. Then a control point was placed on the interior to darken it for a more realistic look, the way the scene basically appeared to the eye.

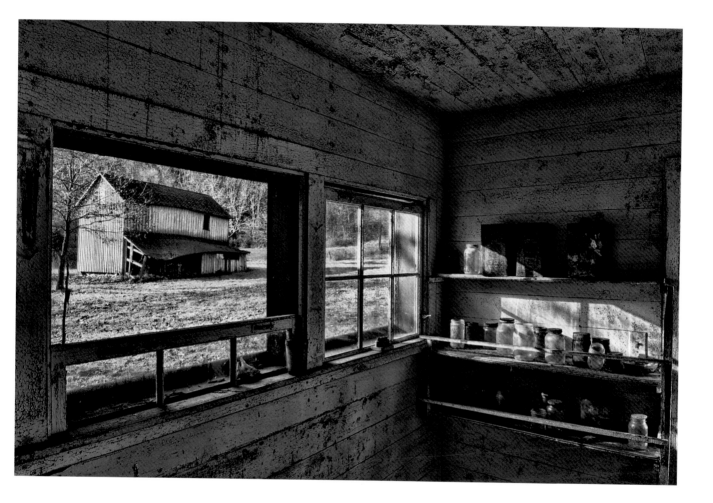

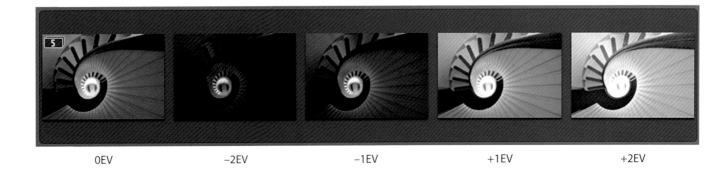

| 0EV | −2EV | −1EV | +1EV | +2EV |

Spiral Staircase

Cabrillo Lighthouse, San Diego, CA

The spiral staircase in Cabrillo Lighthouse in San Diego, is very graphic and detailed. This is why I chose to go straight to the black-and-white presets, choosing "Black and White 2" as a good starting point.

Because of the very wide dynamic range, I increased the Tone Compression to 100, which darkened the bright area at the bottom of the stairs.

In order to get the gritty feel I was looking for, exposure was darkened about 1/2 stop, contrast was increased dramatically (20%), and structure was doubled from 20% to 39%.

Next, three control points were added: two at the bottom of the stairway to bring out detail in the railings, and one at the top of the railing at the upper right to brighten this area to attract the viewer's eye. The scene should be viewed from the top down, not from the bottom up, which is why I darkned the bottom and lightened the top right.

Note: Increasing structure, contrast, or sharpness will intoduce artifacts or bring in unwanted details that you may want to clone out. I kept the final image shown here "as is" to illustrate small artifacts that will be cloned out later.

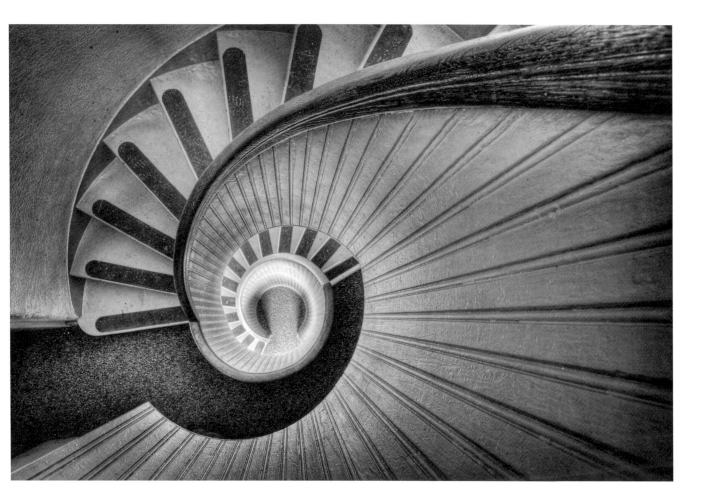

Justine's

St. Michael's, MD

These illustrations go through the process of double processing for a more grungy, highly stylized, interpretive look. Then we'll compare the effects of double-processing in HDR Efex Pro and Photomatix.

First off, there are presets in both applications to begin the process from. It's possible, depending on one's taste, to pick one preset and slightly adjust to get a grunge. Another method is to double process an image, which doubles the effects. After you tone down saturation a bit, a grungy look begins to emerge.

The first screen capture to the right is the preset selected in Nik's HDR Efex Pro. All presets can be created from scratch in the right-hand column, but finding a jumping-off point in the preexisting presets dramatically increases speed of processing.

The adjustments made in the second image to the right brought me into the ballpark of what I was imagining. I desaturated the image, increased structure, and most importantly, changed the HDR method to Dingy (Grungy). I increased the method to taste, then pressed "Save."

Then I reopened the image in HDR Efex Pro. The image came in with the exact same settings, with the previous process doubled. I finished the image by dramatically lowering saturation and increasing white and black points to increase contrast (the same technique as in Photomatix).

Compare the HDR Efex Pro image with the Photomatix image on the next page. The looks are very different. The Nik HDR Efex Pro version is more contrasty. If I wanted that same look in Photomatix, I would have to process one more time using Nik's tonal contrast filter or Lucis Pro, or by increasing contrast in Photoshop.

If I wanted a less contrasty look in HDR Efex Pro, I would do that by increasing or decreasing method strength before the second process.

The results with the two programs are quite different. Both are interpretive. Neither is "better" than the other. As with all things photographic, it's all personal preference.

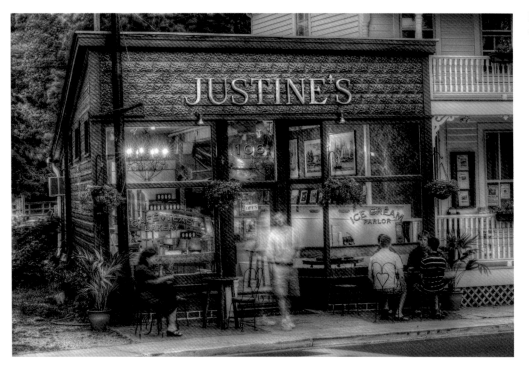

Double-processed grunge
with Nik's HDR Effex Pro

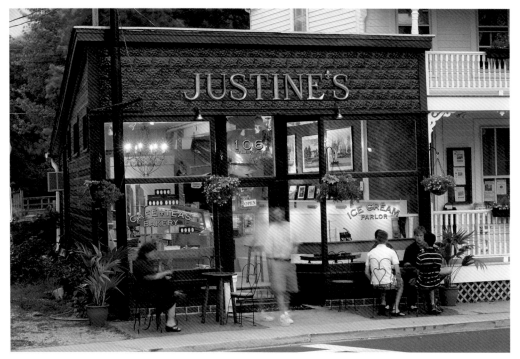

Double-processed grunge
with Photomatrix

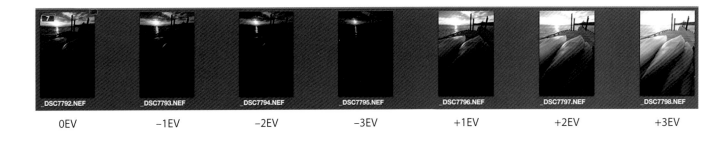

_DSC7792.NEF	_DSC7793.NEF	_DSC7794.NEF	_DSC7795.NEF	_DSC7796.NEF	_DSC7797.NEF	_DSC7798.NEF
0EV	−1EV	−2EV	−3EV	+1EV	+2EV	+3EV

Canoes at Sunrise

Coupeville Wharf, WA

Shooting into a bright early morning fireball is particularly difficult in HDR. The inherent flare and chromatic aberration in such a situation can make image repair very difficult or even impossible. Although this would seem to be such an image situation, I waited until the bright sun was behind a small patch of cloud, which minimized the chromatic aberration apparent in the HDR Efex window at the bottom of the frame. The chromatic aberration was later removed by cloning boardwalk into those areas.

There are a number of customized presets that I saved and discovered work in more than just one situation. All presets appear with the current image in the preview thumbnail. This makes it quite easy to choose one to start with. In this case, one of my custom presets rendered almost exactly what I wanted. Just a few targeted adjustments were needed; the bottom image shows those controls points. From top to bottom: A control point lightened the dark clouds; control points in the water lightened it and evened out the tonality; and the bottom four control points gave the canoes more punch by increasing saturation, contrast, and structure.

The full-page image is the final rendering.

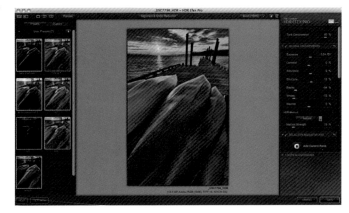

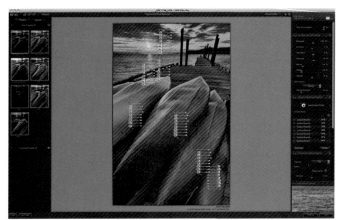

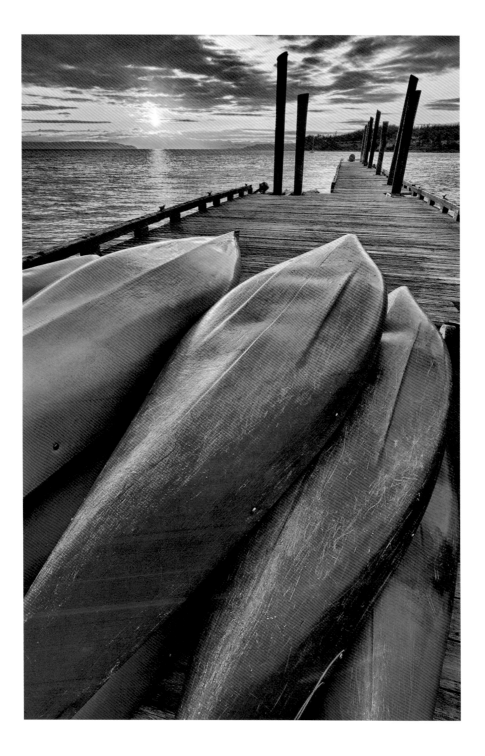

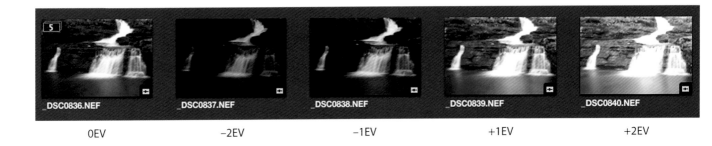

| 0EV | −2EV | −1EV | +1EV | +2EV |

Furnace Falls

Delaware Water Gap, PA

Shooting moving water can be a bit tricky with multiple exposures. It makes it difficult if you want really smooth water. First, I calculated that it would take a −2ev to +2ev exposure range to capture the entire dynamic range. Then I took an educated guess, based on the speed of the flowing water, that I would need at least a one-second exposure at the −2ev setting. That way, all exposures are longer, resulting in an HDR image with glassy water.

As you can see from the first screen capture on the right, the rocks are quite dark and the water is on the verge of being blown out. Even though it looks blown out, the histrogram read that there was detail in there, so I used Nik's Viveza to select and darken the water, also adding structure to increase detail. This was applied in three areas. The control point on the blue/green lichen was placed and adjusted to maximize the amber on the white balance scale. The light was so blue in this gorge area that the effect is not pronounced, but it is apparent when directly compared to the original.

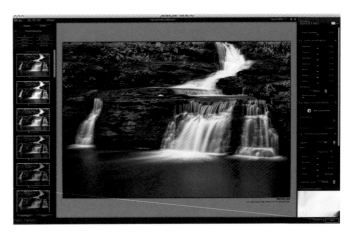

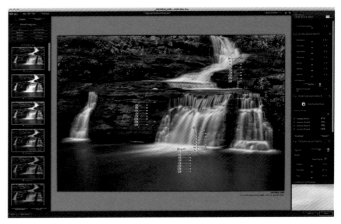

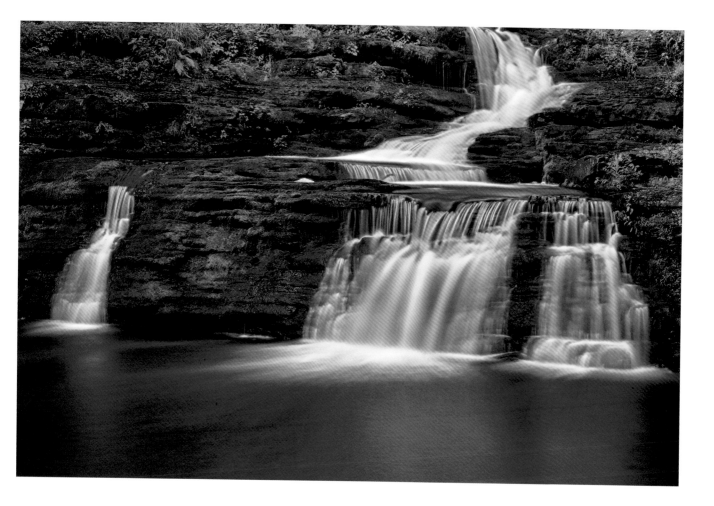

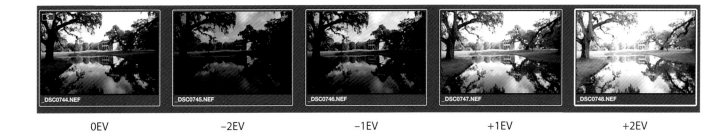

| 0EV | −2EV | −1EV | +1EV | +2EV |

Drayton Hall

Charleston, SC

For this photo, I went with the default preset brought up by HDR Efex Pro, knowing that I intended to go in a different direction. The top image to the right is the default image, but needs a little work. I cloned out the moss at the upper right edge of the frame and several dust specs. Then used the Content Aware move in Photoshop CS5 to take out the moss patches in the reflection. The clouds have several very bright areas that were toned down slightly in Nik's Viveza. The dark corners were lightened in Viveza as well.

Then I applied four textures, adjusting the opacity of each, as well as doing extensive tuning in Uwe Steinmueller's Texture Blending script to get the antique look of the main image on the facing page. Viveza was used to lighten the image.

Texurizing over HDR images can create more possibilities for creative expression. After many hours of searching for interesting and properly sized textures and edges, I came upon my textures and edges of choice: Flypaper Textures and Fly Edges. Every file is simple and subtle, allowing multiple texture layers.

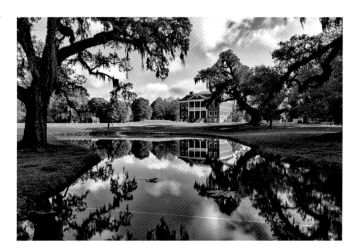

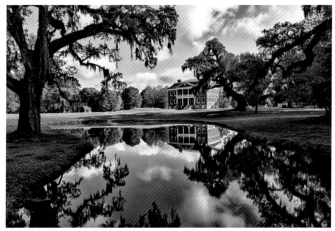

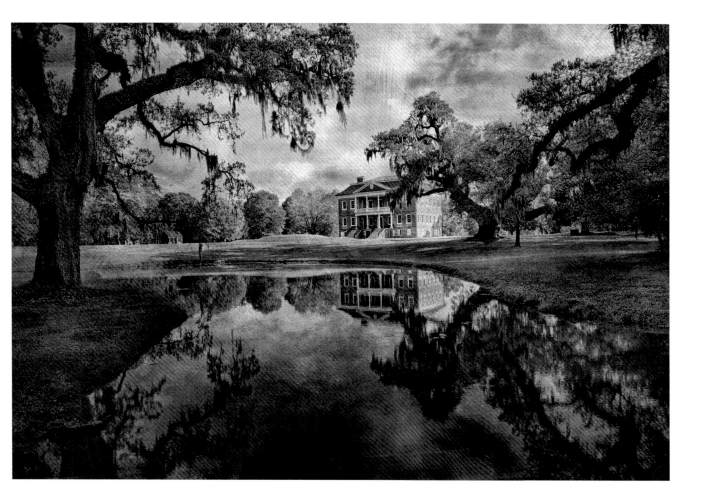

_DSC7923_HDR.tif _DSC7925_HDR.tif _DSC7945_HDR.tif _DSC7938_HDR.tif _DSC7952_HDR.tif DSC7959_HDR.tif DSC7973

Coupeville Wharf

Coupeville, WA

HDR stitched pans are handled a bit differently in HDR Efex Pro than in Photomatix. After processing one HDR image set to taste, save the image settings as a preset by clicking on the Custom tab at the top left in the window, then the "+" sign. A box comes up for you to name the preset.

After you save the preset, it appears in the upper left corner of the Custom Presets box. For each of the remaining thirteen HDR series, when the compiled image is in the window, click "Custom," if you're not already there, then click on the preset you saved (in this case, "360 pan settings"). Each compiled image will have the exact same setting, resulting in uniformity of exposures.

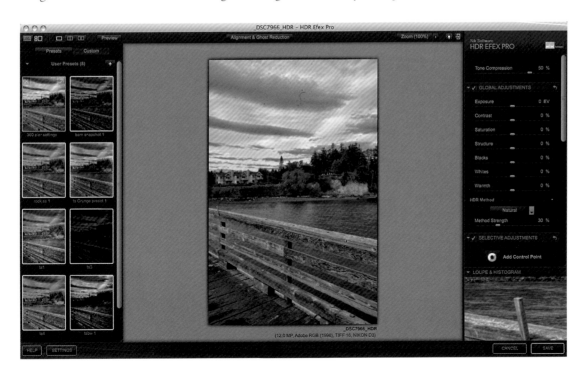

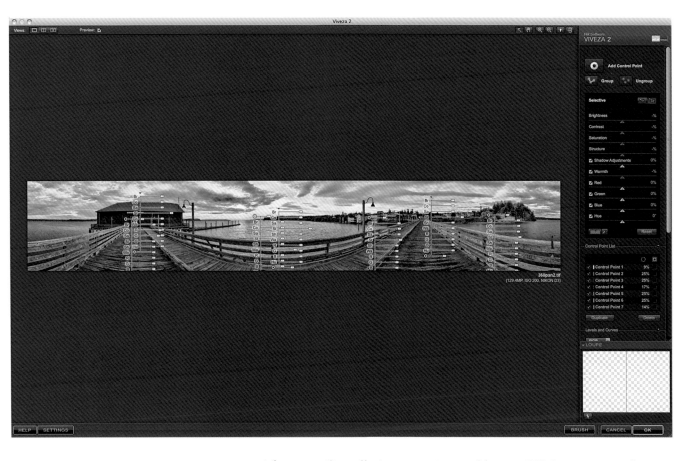

After compiling all ninety-one images (thirteen HDR sequences of seven exposures each), I used Viviza to fine-tune the image. Control points were placed on both long walkways and on the U-shaped area to increase structure. A control point was placed in the sky to add warmth to the morning sky, then control points were added to the trees and small buildings to add contrast, saturation, and structure. Notice how well HDR Efex Pro handles bright skies and clouds. The final image is the following two-page spread.

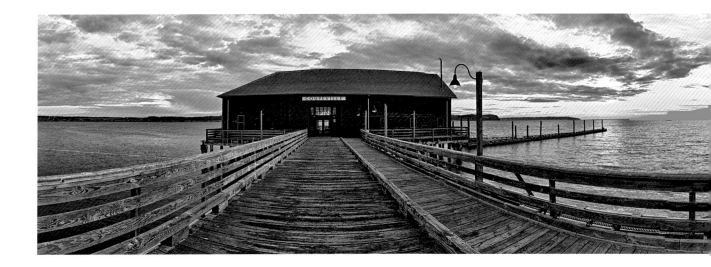

Epilogue

HDR PHOTOGRAPHY IS AND WILL CONTINUE TO BE A MAJOR COMPONENT of image making for the forseeable future. Even during the writing of this book, three new HDR programs have been released, including several iPhone apps! HDR Darkroom and HDR Expose are both excellent and very affordable HDR programs and both are very good for rendering natural-looking HDR images. However, NikSoftware's new HDR Efex Pro and Photomatix both have a much wider range of creative interpretation and is why they were chosen for this book. As we all know, software comes and goes and is always changing. It is hoped that this book will help develop concepts and ideas that will transcend the fleeting and ever-changing world of imaging software.

Tony Sweet
10/20/2010

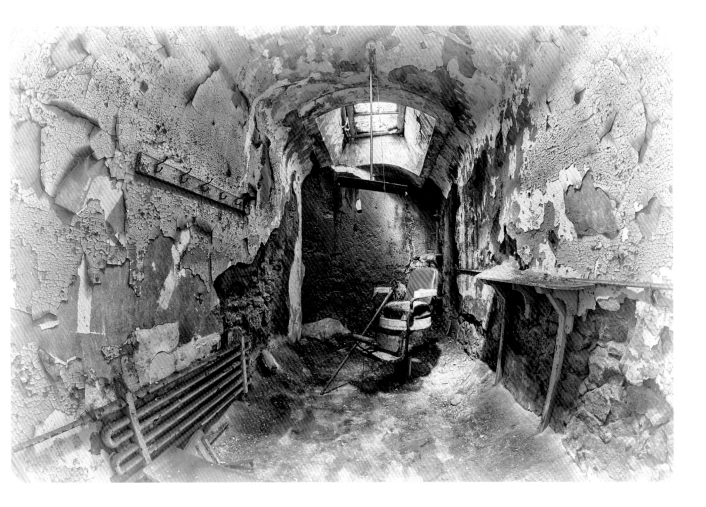

Equipment (and a couple of tips) *for HDR photography*

Camera: A high-quality, low-noise camera is recommended, but any camera capable of bracketing and auto bracketing will work.

For stability, which is absolutely critical in HDR image series, a sturdy tripod and tripod head are essential.

Using a cable release or timer is recommended. Touching the camera directly to press the shutter release will cause movement which you may not be able correct in the HDR software.

For HDR panoramic images a panning head or a leveling head is essential to maintain exact leveling as the camera turns and for keeping exact registration of images through the process. HDR pans involve many images. I've shot thirty-six–, seventy-two–, and ninety-one–image HDR panoramic images. Do not polarize stitched panoramic images; the polarized areas will be uneven from image to image, resulting in very patchy blue skies, which may not be repairable.

Note: Although all images in the sequence are shown on most examples, in order to minimize noise on very high dynamic range situations, I'll select every other image for processing. For example, on a nine-exposure sequence (0ev, –4ev, –3ev, –2ev, –1ev, +1ev, +2ev, +3ev, +4ev), I'll choose to process every other image (0ev, –4ev, –2ev, +2ev, +4ev).

The images in this book were shot with Nikon DSLRs: D3 and D3X.
Nikkor Lenses 14–24mm and 24–70mm were used on all images.
Tripod: Gitzo 3541XLS
Really Right Stuff BH-55 Ball head and Pano Elements Package

For image processing I use Macintosh computers.

Backup strategy: I have one Lacie 2T HD for my original library, two 2T full backups (one onsite and on offsite), and a mobile 2T HD that I take on the road.

I use Apple's Aperture and Photoshop CS5 as my primary image cataloging and processing software.

Product Links

Nikon cameras and lenses: http://nikonus.com

Singh Ray filters: http://singh-ray.com

Macintosh computers: http://apple.com

Nik Software: http://niksoftware.com

Photomatix: http://hdrsoft.com

AlienSkin Software: http://alienskin.com

Topaz Software: http://topazlabs.com

LucisPro: http://Lucispro.com (PC: 64 bit, Macintosh: 32 bit)

Flypaper Textures and Fly Edges: go to http://blog.tonysweet.com and look in the sidebar for the link.

Uwe Steinmuller's Texture Blending script: http://handbook.outbackphoto .com/section_photo_tuning_filters/index.html (under "Artistic Tools")

Reall Right Stuff: http://reallyrightstuff.com

Bogen (Gitzo) tripods: http://www.gitzo.us/

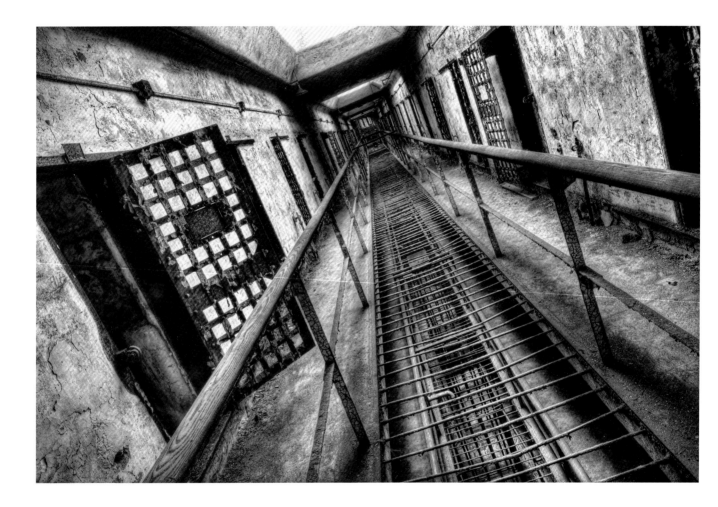

Acknowledgements

The previous sixteen months marked the loss of three close friends.

Barbara Williams Babs was a great photographer, great friend, and kindred spirit. Shared many laughs and great photo hangs. A great photographer, and a supportive and caring friend. Barb had a great zest for life and left us too soon.

Timothy McGinley Initially a drum student in Cincinnati, Timmy became a great and loyal friend. Though he had planned at first to go to law school, Timmy wanted to be in the trenches, and so he decided to be a San Rafael police officer. An injury on the job eventually led to his early demise. Tim's purity and sense of social justice will always be an inspiration.

Robert Bowen Bobby and I shared a house for five years in Cincinnati, where we both were professional musicians. A great friend, musician, and painter, he was just beginning to hit his stride in the NYC music scene. Bobby loved and was committed to his children Bobby and Stella, his music, his art, and his large circle of close friends.

Continued thanks to life partner Sue Milestone, my mom (Mary Sweet), and countless friends, fellow photographers, and vendors, whose support throughout the years has been golden and is greatly and perpetually appreciated. Also, thanks to Mark Allison and Stackpole Books for publishing my ideas.

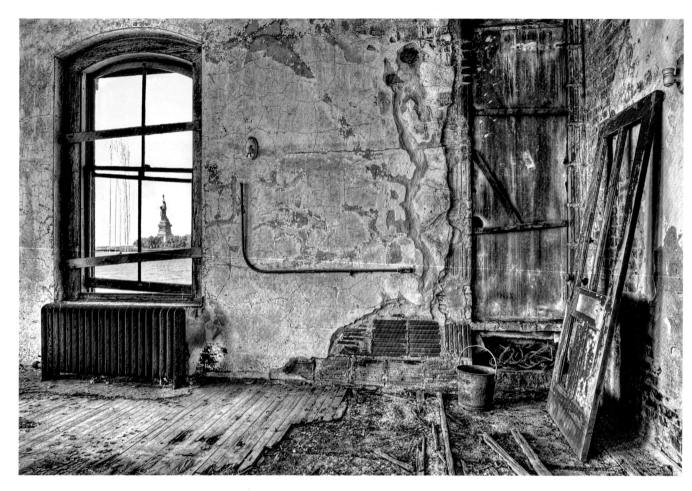

Information on limited-edition fine art prints and location workshops are
available on: http://tonysweet.com

Visual Artistry Blog: http://blog.tonysweet.com
NikSoftware Blog: http://tonysweetniksoftware.blogspot.com/

Facebook: http://www.facebook.com/tony.sweet
Twitter: http://twitter.com/ttsweet